LIGHTING SECRETS FOR THE PROFESSIONAL PHOTO

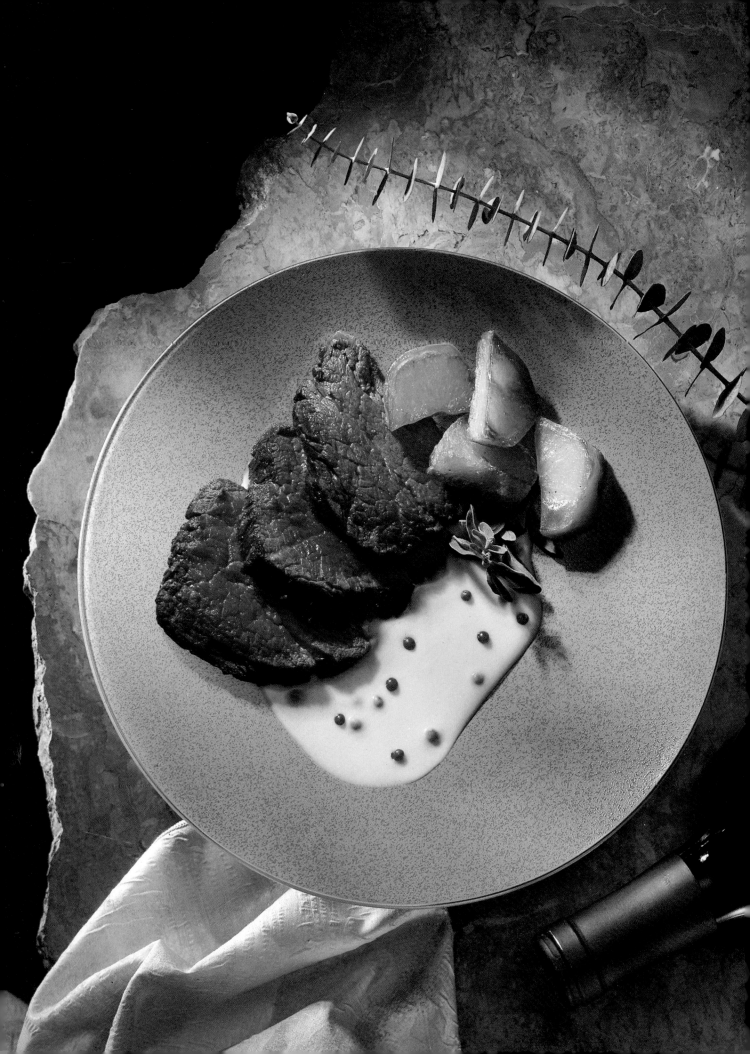

LIGHTING SECRETS FOR THE
PROFESSIONAL PHOTOGRAPHER

Lighting Secrets for the Professional Photographer. Copyright © 1990 by PhotoDesign.
Printed and bound in Hong Kong. All rights reserved. No part of this book may be reproduced
in any form or by any electronic or mechanical means including information storage and
retrieval systems without permission in writing from the publisher, except by a reviewer,
who may quote brief passages in a review. Published by Writer's Digest Books, an imprint
of F&W Publications, Inc., 1507 Dana Avenue, Cincinnati, Ohio 45207. First edition.

94 93 92 91 90 5 4 3 2 1

Library of Congress Cataloging in Publication Data

Brown, Alan, 1956-
 Lighting secrets for the professional photographer / Alan Brown, Tim Grondin,
Joe Braun.—1st ed.
 p. cm.
 ISBN 0-89879-412-9
 1. Photography--Lighting. I. Grondin, Tim, 1949- . II. Braun, Joe, 1959- . III. Title.
TR590.B77 1990
778.7'2--dc20 90-35660
 CIP

Edited by Mary Cropper
Designed by Clare Finney

DEDICATION

To Christie, Ben, and Rachel whose love, strength, and patience held me together; to Naum Karabatak to whom I owe my way of seeing and understanding; and to D. Gorton, who has continually been a guiding light (which doesn't always penetrate the fog).

Alan Brown

This book is dedicated to my parents, Wilfred and Shirley, and the rest of my family, for their love, encouragement, and unwavering support during the best and worst of times.

Tim Grondin

I wish to dedicate this book to Pam, for her love and understanding all through this project. And to my parents, Joseph and Madonna, for their patience and generosity which enable me to pursue a career in photography.

Joe Braun

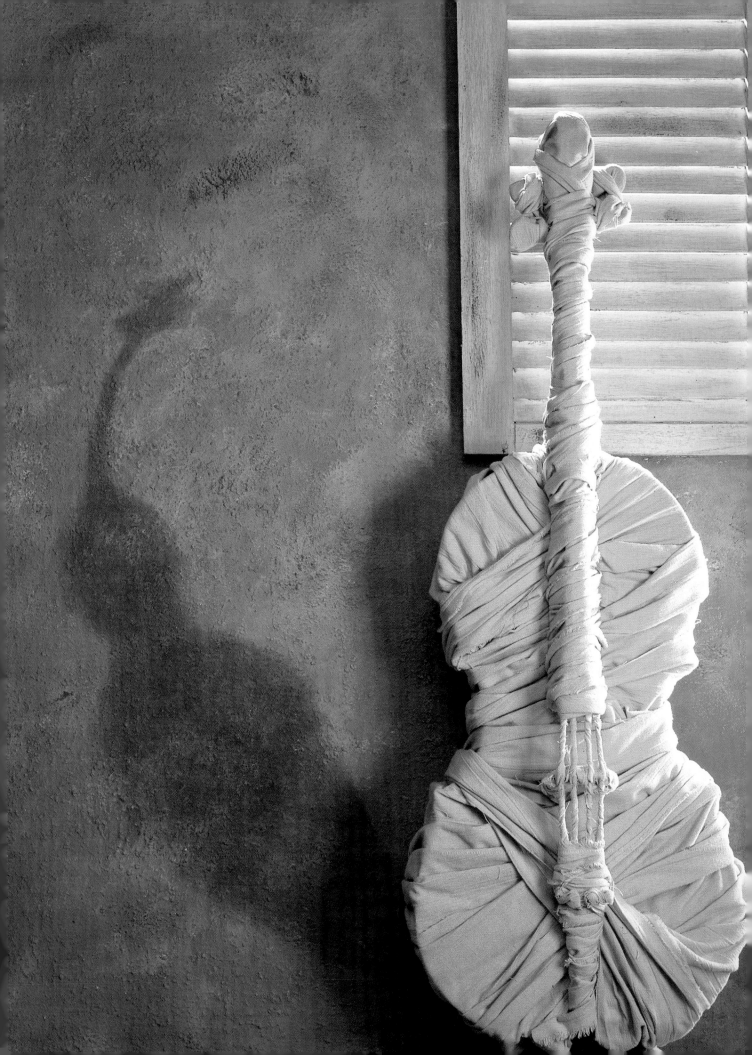

ACKNOWLEDGMENTS

We would like to thank all the employees of PhotoDesign, past and present, our suppliers, and the many talented freelance people who contributed to the making of the images contained in this book.

A special thanks goes to David Lewis, without whom this book would never have happened; and to Mary Cropper for her editorial input, encouragement, and occasional prodding, which helped three visually oriented photographers communicate their ideas through this book.

Contents

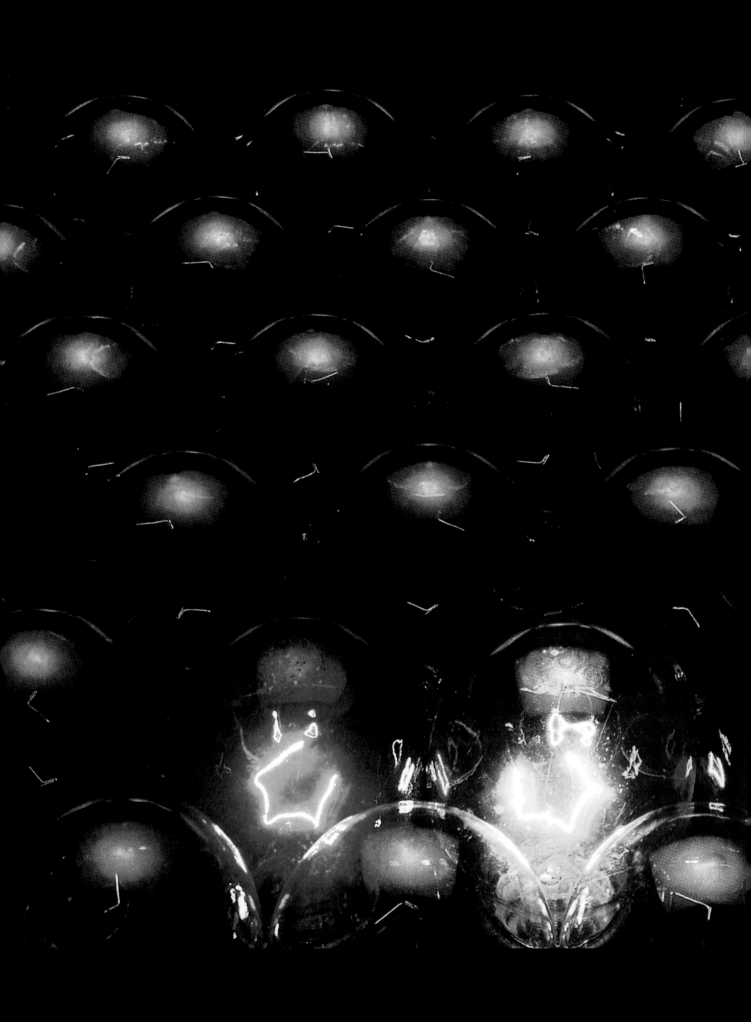

Introduction

Rather than write a traditional introduction, we'd like to give you an idea of who we are as photographers. As you read through this book, you'll see how our personal visions influence everything we do. We hope our interpretations will help you translate your own visions into exciting images.

There are many pretty images out there. While I enjoy looking at them, I never get any further—they are always just pretty images. I enjoy seeing and making images that take the viewers deeper. I want them to see something new or different every time they look at my images. I want people to *need* to stop and look at them, to want to search them for meaning.

I've always been intrigued by the play of light around me. In my work I draw upon my memories of different lighting effects—then try to recreate the feeling of that light in the studio. I have discovered, though, that creating a photo that looks natural doesn't make it very exciting. Pushing the lighting past what's "normal" calls attention to the image and makes the viewer stop and look. I think that my willingness, my eagerness, for the challenges rather than the simple solutions has brought me more innovative, complex assignments—the kind that push me beyond what I know I can do well. Attention to detail, the thrill of the chase, and the need to solve the problem the client brought me all contribute to the style I bring to a shoot.

Self-assignments are my opportunity to experiment and learn different techniques that I can also use on client assignments. The images I create for myself show clients the different directions I can go for them. I don't enjoy shooting the same type of thing all the time. So I have to really stretch myself on self-assignments to keep from being stereotyped in my regular work.

I never *really* got into photography until my first formal class during my final quarter at Michigan State University before graduating with a B.A. in advertising. But that class ignited something within me—a fire that still burns intensely. Six months after graduation, I decided advertising was not the field for me. At twenty-four I bought my first "serious" camera and enrolled in photography school.

I don't feel that being a "late bloomer" in photography hindered me at all. Anyone can master the technical aspects necessary to be a photographer in a relatively short time. The characteristics that make a photographer successful are more general and develop over a lifetime of experiences, observations, education, and interactions with our physical and social environments.

The elements of a good photograph are everywhere: the fascinating interplay of light and shadow, the subtlety of texture, the muted hues in a background, a sudden splash of color, the movement inherent in nature, or people's daily lives, the whimsy of life itself. Pursuing and capturing these elements is both fulfilling and frustrating. But all of the inconvenience, frustration—and even pain—in producing images is worthwhile when you capture a truly compelling image on film. The opportunity to create compelling images, ones that move people, elicit emotions, communicate a message or mood, was the most important factor that attracted me to photography. I hope these images will outlive me and continue to affect people after I'm gone. And that's about as much immortality as is humanly possible.

Photography is about light; it's more important than film or cameras or any of the other gadgets I use. When I was a photography student, I would go out and observe light and record interesting or unusual situations in black and white. I photographed all kinds of light: light reflected in wet gravel, light streaming through windows, the street lights after dark. This is a valuable exercise for a photographer, because it makes you appreciate the unique characteristics and the range of emotions that each different type of light conveys.

Light is also a tool in the studio. I use light to capture the essence of products and people. I try to light my subject with one of the types of light I remember from my observations in nature. I then shape and refine that light to define the important features of my subject. But I try to do it in a way that doesn't lose the mood I want to get across.

I think the key to using light successfully is being able to balance rendering detail against creating a dramatic effect. You can get too caught up in trying to render every little detail of a subject and end up with lighting that has no mood or emotion. At the other extreme you can use light solely for its dramatic effect and too many of the important details of the subject are lost or obscured. You have to be able to light a subject so that you show its features clearly *and* capture the mood or emotional impact of lighting.

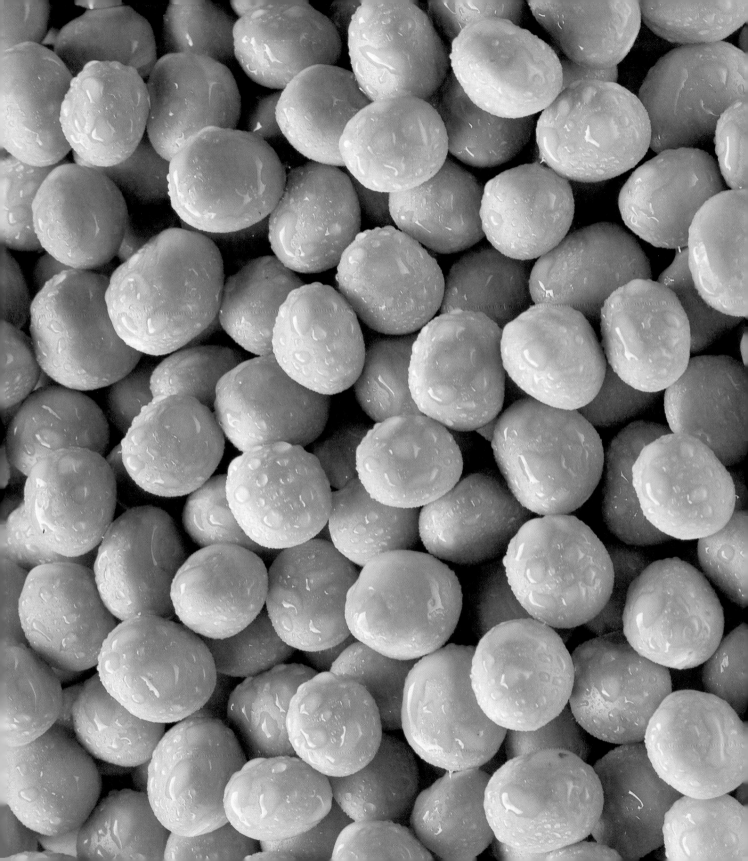

Tools

To make it easy to follow the demonstrations in this book, we've listed the types of equipment and the terms we've used, along with some descriptions of how the equipment was used. Although all the lighting diagrams are labeled, the "Lighting Symbol Key" in this chapter describes the basic symbols used in the lighting diagrams and gives some additional detail on the equipment that each symbol represents.

TOOLS AND TERMS

Accent Light: A small light source used to show a specific area or feature in a shot; e.g., to bring out the edge of a subject.

Background Light: Light(s) illuminating the background of the photograph.

Backlighting: Light directed toward the camera from behind the subject so that light either passes through the subject or illuminates its surface texture.

Bank Light: Light source made up of several individual lights behind a single square or rectangular diffuser. Lights may be used in any combination.

Barn Door: Flaps that attach to the rim of a light and can be adjusted to control the amount and direction of the light.

Barn-Doored Down: Controlling the light spilling off to the edges, blocking part of the beam. See also Barn Door.

Bestine Rubber Cement Thinner: Brand of solvent used to produce fire effects.

Black Board: A black mat board; the opposite of a reflector, used to "absorb" light from an area.

Color Tints (Simulated Watercolor Washes): Transparent color placed over areas of a computer-generated image so that the light areas will hold color but the shape of the image is not observed by the color.

Colored Gel: A transparent colored material which changes the color of the light passing through it.

Diffuser: Material placed over or in front of a light source to soften and spread light.

Diffusion (or Diffusing) Screen: A wood frame constructed of 2" x 2" lumber and covered with a frosted acetate material. Light strikes the acetate from one side, diffuses and spreads out, then passes through the other side to the subject. Used to produce a broad, even light source similar to a light box. Very useful in lighting large reflective subjects because they produce a broad, even reflection and give a smooth, continuous look to the reflective surface(s). They also reduce the contrast of whatever light source is put through them.

Dither Effect: The way a computer can represent the transition between one tone and the next in an image so that they are not sharp transitions.

Electronic Flash Head: Light source for strobe lighting.

Electronic Still Video Camera: A camera that uses a charge-coupled device (CCD) or light sensitive electronic sensor to convert light into an analog, video signal on a two-inch floppy disk of video tape.

Fall Off: Letting light gradate into shadow; or the area where the illumination gradates into shadow.

Feathering a Light: Turning a light source slightly so the subject is illuminated by the edge of the beam, rather than by the center. The light produced is usually slightly more diffused and less intense than straight lighting.

Fill Board: A reflective cardboard surface used to bounce light into a subject to lighten existing shadows without causing secondary shadows.

Fill Card: See Fill Board.

Fill Light: A supplemental light source (less intense than main light) used to lighten shadow areas without casting secondary shadows.

Film Recorder: A device that translates digital image data from a computer to conventional photographic film through a digital to analog conversion process.

Flash: Made by firing strobes once while shutter is open.

Fog Machine: A device that makes smoke or vapor with dry ice, oil, or chemicals.

Frame Grabber Board: A device attached to a computer system that accepts and converts a video, analog signal into digital information.

Frosted Acetate: Specific type of diffusing screen.

Gobo: Board or other device to block light off the camera lens or parts of the subject.

Gold Board: Gold-colored board used to warm up light that is bouncing off it.

Grid Spot: A honeycombed attachment made of flat, black material to direct light in a narrow beam. The smaller the size of the honeycombs, the narrower the beam.

Internal Diffuser: Additional diffusion placed inside a light bank between the light source and the outer panel in order to soften and spread out the light.

Key Light: The most intense or the brightest light source in a photograph; it controls direction of shadows.

Kicker: "Shorthand" term for a kicker light. See Accent Light.

Lamp Head: Light source with a flash tube and/or tungsten bulb.

Light Bank: See Softbox.

Light Box: Attachment for electronic flash head that produces a

very soft, very even light much like that of indirect light passing through a window—quite flattering to most subjects. Light from flash head bounces off material (usually silver or white) inside light box then passes through sheer, white fabric or acetate to subject.

Modeling Lamp: A tungsten light within a strobe head to provide continuous light with approximately the same position and quality as a strobe. Used to position lighting before checking with a Polaroid which captures the image illuminated by a split-second flash.

Opalite: The brand of flash head with an 18 1/2-inch round reflector that we use.

Pastel Filter: A filter that has a somewhat grainy texture etched into its surface that gives an ethereal look to a photo.

Pop: Slang term for a flash. See Flash.

Power Pack: A unit containing capacitors to store an electric charge with enough power to jump between two points in a flash tube when released, providing a brief, bright flash. Also has sockets for connecting light heads and various switches and knobs to control the output of power to light heads.

Quartz "Hot Light": See Tungsten Light.

Reflector Board: Board that bounces light back into certain area(s) of a subject, usually into a shiny, reflective surface.

Reflector Card: See Reflector Board.

Rim Light: A light coming from behind or from the back and side of a subject used to highlight the edge or perimeter of the subject. See also Backlighting.

Screen: See Diffusion Screen.

Scrimmed Down: Similar to Barn-Doored Down, but using a free-standing device instead of one attached to the flash head.

Sharpening Algorithm: A method by which a computer program increases the contrast between two adjacent tones, reducing the amount of dither and giving an apparent increase in sharpness.

Silver Reflector Board: A reflector board covered with silver material to increase reflectivity while maintaining same color.

Snoot: A circular or cone-shaped attachment fitted over a strobe head to narrow the beam of light.

Softbox: Light source in an enclosure with a front panel composed of translucent material that diffuses the light passing through it, and with reflective sides and back.

Spot Light: Narrow beam of light provided by a very small or tightly focused light source.

Spotted Position (to have in a): To make the beam of light coming out of a flash head as narrow as possible.

Strip Light: Elongated softbox, usually made in a ratio of 1:3 or greater.

Strobe: Light source that illuminates with a powerful burst of light for a very short duration (a flash) that provides Kelvin temperature

of 5,000-5,500 degrees, approximately equal to the sun at noon.

Tent: A structure created to envelop a product and reflect a continuous, uninterrupted surface into the product.

Tungsten Light: Light source that provides a constant illumination by using a glowing tungsten filament suspended in gas that's enclosed in glass. Generally provides color temperature of 2,400 to 3,400 degrees Kelvin.

Umbrella Reflector: Collapsible reflector used to enlarge or diffuse a light source, such as a flash head. Umbrellas may have a white bounce surface (low contrast), a white and silver bounce surface (medium contrast), or a silver bounce surface (high contrast). The flash head is aimed into the inside surface of the umbrella and bounced back out at the subject. The angle of light can be varied from 75 to 125 degrees by moving the flash head closer to or farther from the inside bounce surface.

View Camera: Large format camera that allows precision focusing on its ground glass; generally uses a large-format sheet film. Allows delicate and precise perspective control through adjustments of both the lens and the back of the camera.

White Board: See Fill Board.

White Bounce Card: See Fill Board.

Work Light: Light placed on a set to provide illumination for composition and focusing; not used in final lighting for film exposure.

1

LIGHTING SYMBOL KEY

1. Electronic Flash Head
 No diffusion or reflector.
 High contrast, very scattered omni-directional (180 degrees).

2. Electronic Flash Head with 18½-inch Round Reflector
 Normally used with diffuser indicated in front of light;
 40-degree light angle without diffuser & high contrast;
 90-degree light angle with diffuser & medium contrast.

3. Electronic Flash Head with 7-inch Round Reflector
 65-degree light angle & high contrast.

4. Round "grid" disc often used with 7-inch reflector to screen
 down the angle of light. Sizes are: 3-degree, 5-degree, 10-degree,
 20-degree, 30-degree, & 40-degree.

5. View Camera

6. Background Support Stand

2

3

4

5

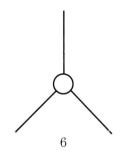

6

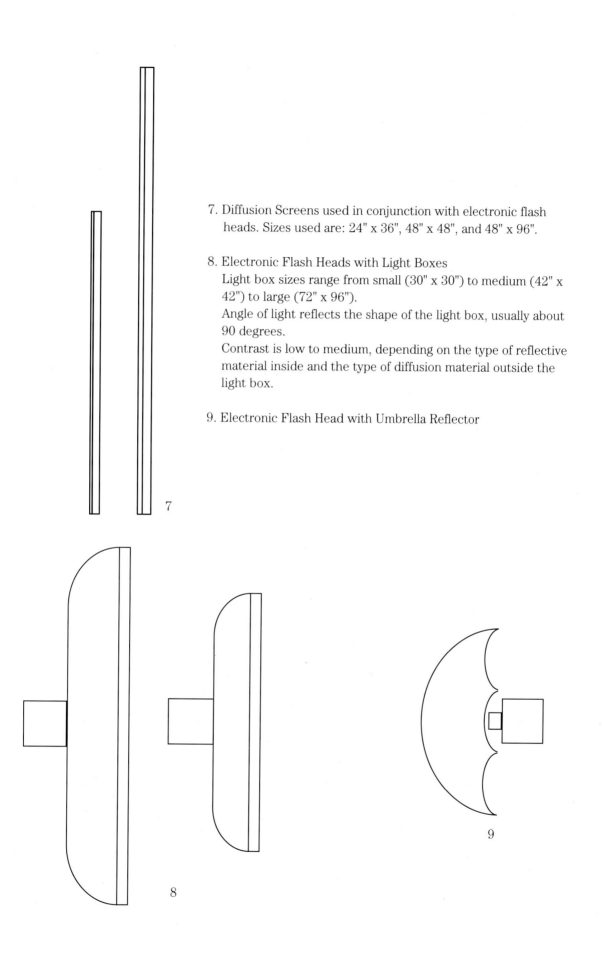

7. Diffusion Screens used in conjunction with electronic flash heads. Sizes used are: 24" x 36", 48" x 48", and 48" x 96".

8. Electronic Flash Heads with Light Boxes
 Light box sizes range from small (30" x 30") to medium (42" x 42") to large (72" x 96").
 Angle of light reflects the shape of the light box, usually about 90 degrees.
 Contrast is low to medium, depending on the type of reflective material inside and the type of diffusion material outside the light box.

9. Electronic Flash Head with Umbrella Reflector

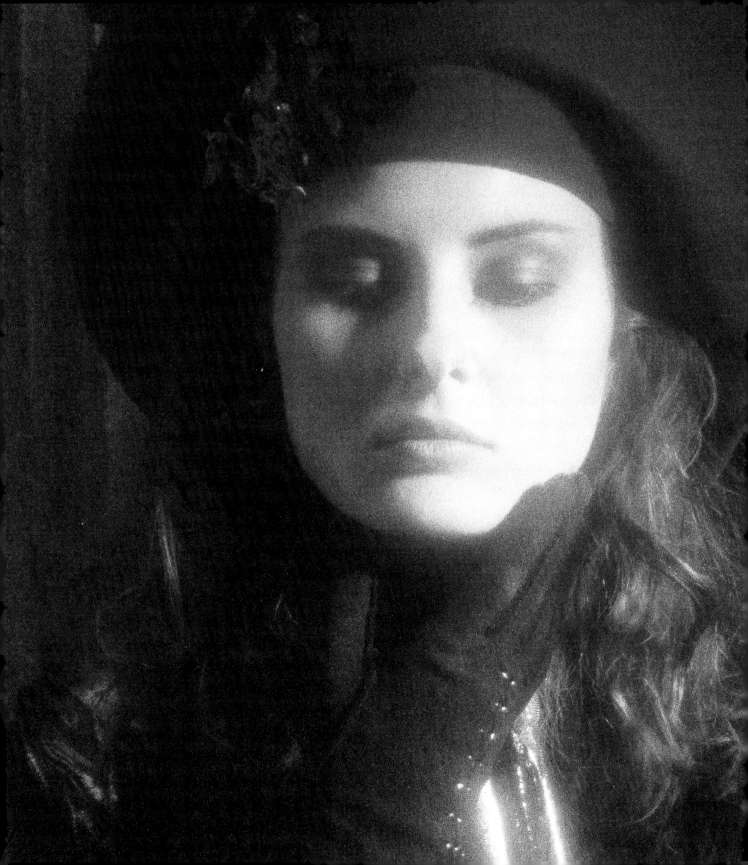

The Whys of Lighting

Here's a quick look at some of the thinking process that goes into how each of us approaches lighting overall. We have a lot in common, but each of us works with lighting a little bit differently. For convenience, we've divided lighting into two broad categories. The first includes shoots where we've got a clear, specific lighting plan in mind and follow that—fairly closely—all the way through. The second covers shoots where we don't have a very specific lighting plan and those where something happens that dramatically changes the lighting approach.

PLANNING THE TRIP IN ADVANCE

JOE: When I have an advertising assignment, I generally try to plan my lighting strategy well in advance. I usually have a pretty good idea of the type of lights I want to use and where I am going to position them before I start to put lights on the set. It's almost as if I have a sketch pad in my head.

There are three approaches that contribute to developing this mental lighting diagram. The first is previsualization or forming a mental image of what I want the photo to look like. Sometimes I get a really strong mental picture, maybe from something I've seen before or even dreamed about, which usually gives me 90 percent of what I need to preplan lighting a subject. Other times the picture is less clear, maybe no more than a glow behind the subject or an image of the subject sitting on a certain type of surface. When that happens I rely more on the other two approaches to preplanning a lighting strategy.

The second approach is drawing on my experience lighting other subjects. It might be a problem I had trying to get a detail to show up or a lighting setup that worked particularly well with a similar subject. It might be the successful way I lit a certain type of background. I don't mean to sound as if I light using a predetermined formula. In fact, I think formula lighting does not work, because each subject—no matter how similar to a previous one—has its own unique characteristics and problems. I do believe, however, that drawing on past experiences can be a valuable tool for dealing with new problems that arise.

My third approach to preplanning my lighting strategy is observation. I like to look at the subject by itself before I even attempt to put it on a set. I study it, looking for features I want to play up and those I might want to hide. I watch how light (room light) strikes different edges and surfaces. I want to see how reflective or non-reflective it is, how transparent or how opaque. All these observations affect my plans.

I go to the trouble of planning my lighting because I owe it to both my studio and my clients to do a job in an expedient and professional manner. (Clients understandably get very nervous when they've been in the studio for an hour and the photographer is still scratching his or her head. They're spending their money for my time and they ought to feel I'm using it well.) Preplanning is also essential for the smooth and efficient operation of a photography studio. If I know in advance what types and amounts of lighting equipment I'm going to need, it helps enormously with scheduling, setting up rentals, finding special equipment, arranging for manpower, and pricing the job.

ALAN: I started my business doing many jobs where I had to produce images that resembled the results art directors had promised their clients. Over time I've begun to get assignments that left more room for interpretation, where I was able to include my own visions

It is generally true, however, that when I have assignments from art directors, the clearer the objectives, the easier it is for me to plan the lighting for a shot. Only when you understand what your client wants you to achieve can you plan your shot, decide on props, and work out your lighting.

In order to start a shoot, I need to have a clear idea of the objective or concept. This doesn't need to be elaborate or detailed. With a concept as simple as "make an interesting image for the chamber orchestra's season poster," my mind immediately starts running through techniques, those I've already tried and some I haven't, to help me pull off the shoot. Is the client looking for an image that's moody or open? Or does the client want a simple, clear shot of the product? The answers to these questions point the way toward the methods available to solve the assignment.

When you plan a shot without a clear concept, you will probably run into trouble quickly. The shot won't work because it won't meet the client's objectives, and it won't meet the client's objectives because

you didn't understand what the client wanted. If an art director doesn't make it absolutely clear what he or she wants the shot to achieve, how can I get the shot right unless I make a lucky guess?

Only a great concept executed well produces a great shot. You owe it to everybody involved — the art director, the client, and yourself — to strive for nothing less than a great idea and a great execution every time.

I feel that the relationship between an art director and a photographer should be a collaborative effort. Good collaboration breeds good photography. There is a give-and-take, a fine-tuning process that takes place as I shoot. Part of that method is to be open to input offered by my clients, partners, and assistants. While I don't always use the advice directly, often it makes me rethink and reexamine my approach.

Then there are the times when the art director starts to tell me exactly how to set up, define, and light the shot—and I think that his or her plan is very weak. When this happens, I must explain to the art director why his or her ideas may not work. But before I can do this, I must have a better plan *and* be able to communicate why my plan will be more successful. This is, after all, why someone hires me— my vision and expertise as a photographer.

TIM: When photography was just a fun pastime, I used to take my camera out for the afternoon and take pictures of anything interesting I ran across. Occasionally I would find one very striking image—in which the composition, lighting, and at times, the "decisive moment" all came together—among the other photos I shot.

Today, I can't afford to wait for the one-in-a-hundred happy accident to help create a successful image. Not that we don't welcome and make use of happy accidents— we do—but we can't depend on them. The money and time expended in trial and error attempts to achieve an effect is not acceptable in advertising photography.

Instead of depending on chance, a professional photographer needs to preplan, to have an idea where he or she is going. The first step is having a relatively clear idea of what the desired result is. Do you need a clean, clear depiction of the product for packaging? Or should it be a more soft-sell approach designed to evoke a certain mood or feeling? In other cases we're not working with a product at all; the mood of the photograph itself may be the concept. Whatever the goal of the shoot, you must make sure you're aiming for it from the start. The most beautiful, technically perfect photograph will be a failure if it doesn't produce the intended effect.

Once you know where you're going, you have to plan specifically how to get there. I find that I ask myself a lot of questions before I begin a shoot. What direction should the light come from? How dark or open should the shadows be? What features of the subject need to be accented? Do I need to use reflectors to change the appearance of highlights in reflective areas or the relative darkness of shadows by adding or subtracting light? Should I use special effect lighting to enhance the mood? Colored gels on accent lights could put small, colored highlights in key areas to emphasize or add interest.

Certainly, you can't plan the exact placement and type of each light or always select the best technique in advance. But a plan gives you a starting point, a framework to use instead of just groping along blindly. Adjustments and changes are inevitable, but a firm direction is vital.

An inexperienced or amateur photographer can probably come up with six to twelve quality images for his or her portfolio. But a professional photographer has to be able to produce a quality image every time as well as translating concepts into a compelling photograph. Happy accidents should never be more than bonuses. True professionals know how to work toward successful results without depending on serendipity.

19

FOLGERS COFFEE SHOT

WHAT I WANTED TO GET:

This was an assignment to photograph a mug of Folgers coffee sitting on top of a desk for a brochure. The art director wanted an early-morning, first cup of coffee look for the shot to fit the theme of the promotion.

HOW I GOT IT:

Knowing that I needed to suggest that it was early morning, I placed a flash head with a 40-degree grid spot attachment and a warm gold gel to the right rear of the set. I aimed the light through an old window frame to add some "morning light through the window" shadows. I placed a small diffusion screen to the rear of the set, leaning it toward the camera until I saw a smooth reflection in the surface of the coffee. This would both make the coffee look more appealing and draw the viewer's eye toward that area of the picture. Finally, to make sure it was quickly apparent that this wonderful coffee was Folgers, I used a flash head with a 10-degree grid spot attachment placed at the left front of the set to illuminate the logo on the mug. I feel the final image with the warm, golden light suggesting a good morning, the attractive look of the coffee in the mug, and the readability of the Folgers logo gave the art director what the shot needed to make the theme work.

Client: Procter & Gamble
Photographer: Joe Braun
Art Director: Ray Mueller
Agency: Northlich Stolley LaWarre

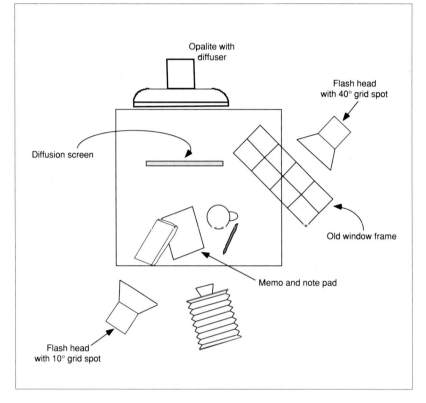

Opalite with diffuser

Flash head with 40° grid spot

Diffusion screen

Old window frame

Memo and note pad

Flash head with 10° grid spot

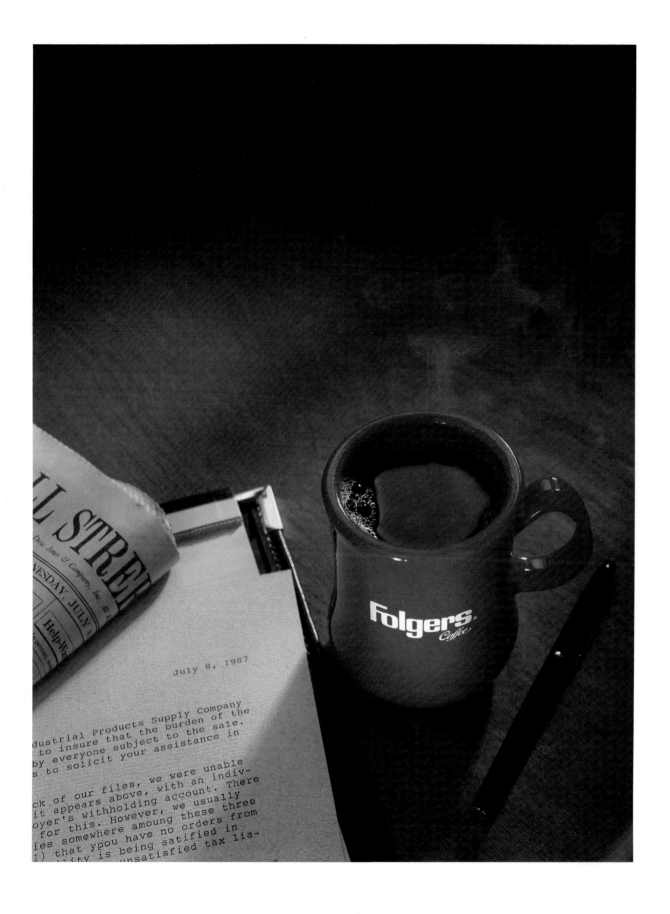

NUTCRACKER POSTER SHOT

WHAT I WANTED TO GET:

The Cincinnati Ballet Company held a design competition for a poster promoting the company's annual production of *The Nutcracker* ballet. The designer who I teamed up with wanted to create a visual symbol for the title of the ballet. The symbol had to be very nontraditional because the company was seeking a very up-to-date, trendy, and unique look for their promotional poster. We ultimately chose an image of a pair of ballet shoes falling out of an open nut. To make the image even more arresting, we played with the sense of scale by making the shoes smaller than the nut. This would capture the viewer's attention with its visual contradiction: people know shoes can't be smaller than a nut, but here they are.

HOW I GOT IT:

The image of the shoes was created on one camera and the film was then transferred to a second camera aimed at the walnut, both exposed on the same piece of film. The hardest problem was getting an interplay of light on an object as small as a walnut. I had to add snoots with very small openings to hit on small areas of the walnut, including the inside edges of the nut. I think the end result justifies the effort as the design concept has been carried out in a very arresting way.

Client: The Cincinnati Ballet Company
Photographer: Alan Brown
Art Director: Tony Magliano
Agency: Martiny & Co.

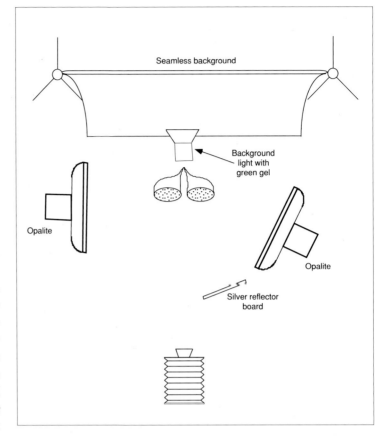

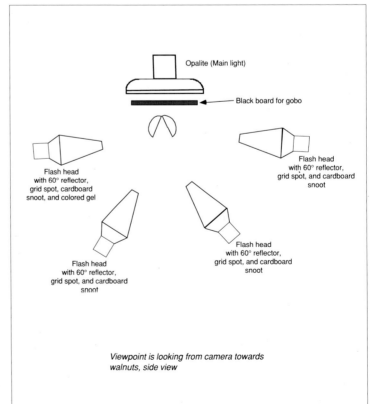

Viewpoint is looking from camera towards walnuts, side view

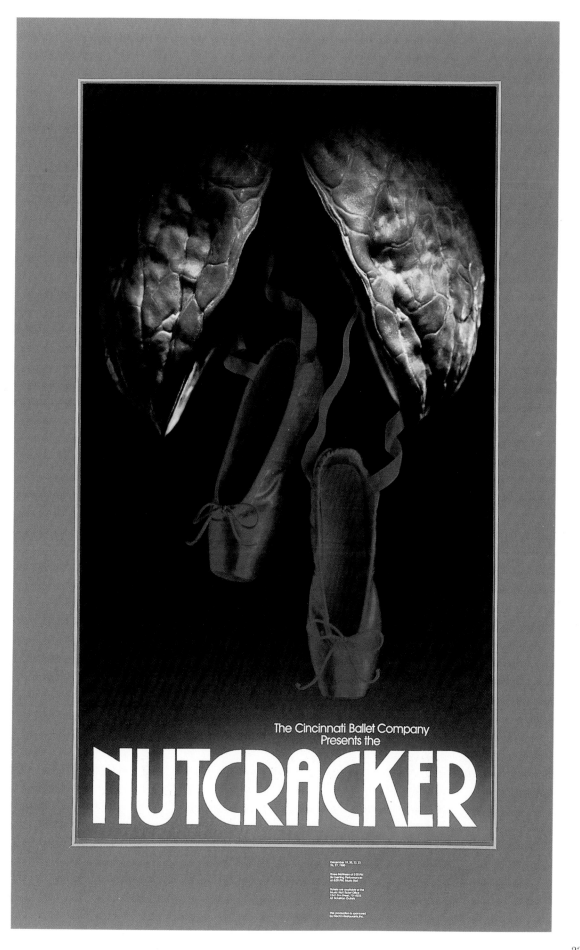

The Cincinnati Ballet Company
Presents the

NUTCRACKER

RED TRUMPET SHOT

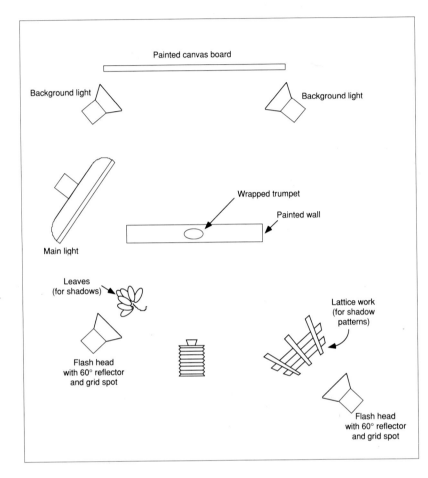

Painted canvas board

Background light

Background light

Main light

Wrapped trumpet

Painted wall

Leaves
(for shadows)

Lattice work
(for shadow
patterns)

Flash head
with 60° reflector
and grid spot

Flash head
with 60° reflector
and grid spot

WHAT I WANTED TO GET:

I got the assignment to create the Cincinnati Pops Orchestra's annual promotional poster. Every year they need a new poster with strong visual impact to attract attention (and subscribers). For this poster they wanted to use a trumpet in an interesting and different way. The art director and I agreed that a wrapped trumpet on a window sill in a surrealist-style poster would get the results they wanted. We felt that a wrapped trumpet would be thought provoking because it's not what people expect: what is a wrapped trumpet? We'd create another visual contradiction—a photograph that looks like a painting.

HOW I GOT IT:

Using the texture of the cloth and paint gave the image an illustrative feel that heightened the surrealistic effect. Several elements helped to create a painterly look for the image: the rich color on the wall, the moody, surreal canvas cloud background, and the use of a semi-hard main light source to create the shadows cast on the wall. Everyone loved this—it was unusual, eye-catching. And I felt that I'd come up with more than just a nice image— it was one that would make people stop and think about what they were seeing.

Client: Cincinnati Pops Orchestra
Photographer: Alan Brown
Art Director: Liz Kathman Grubow
Design Studio: Libby, Perszyk, Kathman
Set Painter: Guntis Apse
Stylist: Regina Mikonis

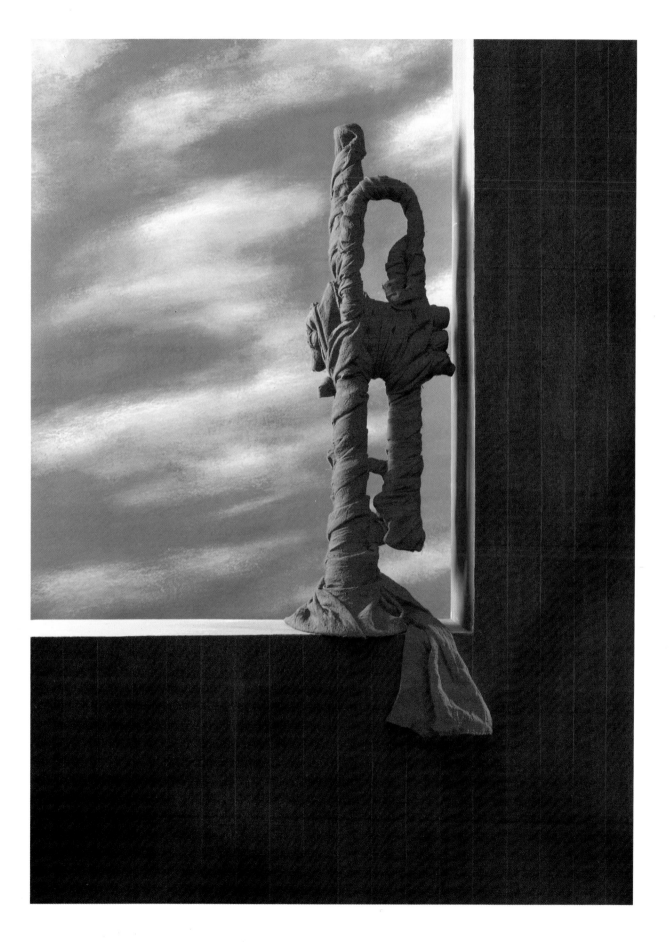

DAYLAY EGG SHOT

WHAT I WANTED TO GET:

For the cover of a brochure for the Daylay Egg Farm I needed to blend two images: the background with type laid on it (all two dimensional) and the egg (three dimensional). The challenge here is to blend these two so smoothly that the viewer will do a double take. At first it looks like nothing is real; everything is just painted on. Then it suddenly sinks in that the egg is rising above the background! And the viewer is hooked.

HOW I GOT IT:

I placed a single light source (see diagram) so it gave texture to the background by skimming the raised pattern. The same light source gives shape to the egg by being much brighter on one side with light reflected back in on the other. The reflected light slightly brightens the left side of the egg and leaves a shadowed area about three-quarters of the way across on the left side. There are three very different light values on the egg, but the shift of light across the egg is very soft as it goes from the far right side over the curve of the egg. A bright *area* rather than bright spot gradually falls off into shadow, becomes a fairly dark shadow, then grows brighter again. This smooth transition from one area to another enhances the feeling that this is a round object.

I also had to achieve just the right density for the shadow cast by the egg. If I'd used shadowless light-ing there, the egg would have looked exactly like a flat cutout laid on a background. So the shadow tying the egg to the background had to have enough density to give the egg dimension, but had to be soft and open enough that all the A's (for AA eggs) would be very readable. To do all this and let the texture of the background bleed through, I had just enough light reflected back in to give a soft but well-defined shadow. I used a pretty small, fairly crisp light source because the egg is, naturally, pretty small. If I'd used too large a light source, it would have washed out the background.

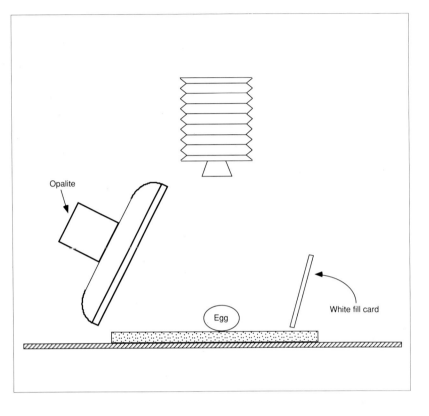

Client: Daylay Egg Farm
Photographer: Tim Grondin
Art Director: Mike Hensley
Agency: Business & Industrial Marketers

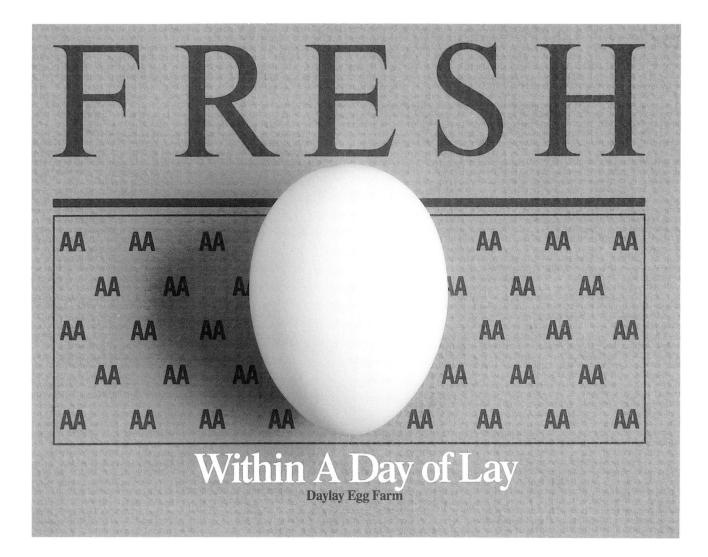

FRESH

AA AA AA AA AA AA

AA AA AA AA AA

AA AA AA AA AA AA

AA AA AA AA AA AA

AA AA AA AA AA AA AA AA

Within A Day of Lay
Daylay Egg Farm

RED SOCK SHOT

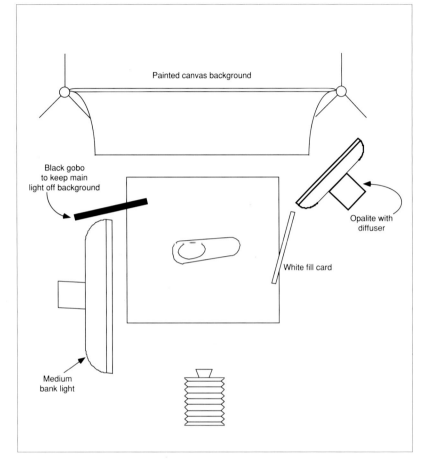

Painted canvas background

Black gobo
to keep main
light off background

Opalite with
diffuser

White fill card

Medium
bank light

WHAT I WANTED TO GET:

I got an assignment to photograph a red sock that doubles as a slipper. The finished shot would be used for the product's packaging. The client wanted to have a model wearing the sock posed in such a way that the product's unique tread design would show. They also wanted the model to wear blue sweatpants, and have the bottom of the pants leg showing. To meet these requirements and fit the vertical format of the package, the model had to pose as if taking a step.

HOW I GOT IT:

I began by lighting the sock and leg from the left with a medium bank light in order to show off both the texture of the sock and emphasize the unique tread feature. Next I lit the right side of the painted canvas background so there was good separation between the sock and sweatpant leg and the background. Finally I added a small white card to the right of the sock and leg to lightly fill the shadows. I like the way this turned out because I managed to work within extremely tight constraints to create an image that met the designer's format and also looked good.

Client: Totes
Photographer: Joe Braun
Art Director: Jim Makstaller
Design Studio: Design Centre of Cincinnati

28

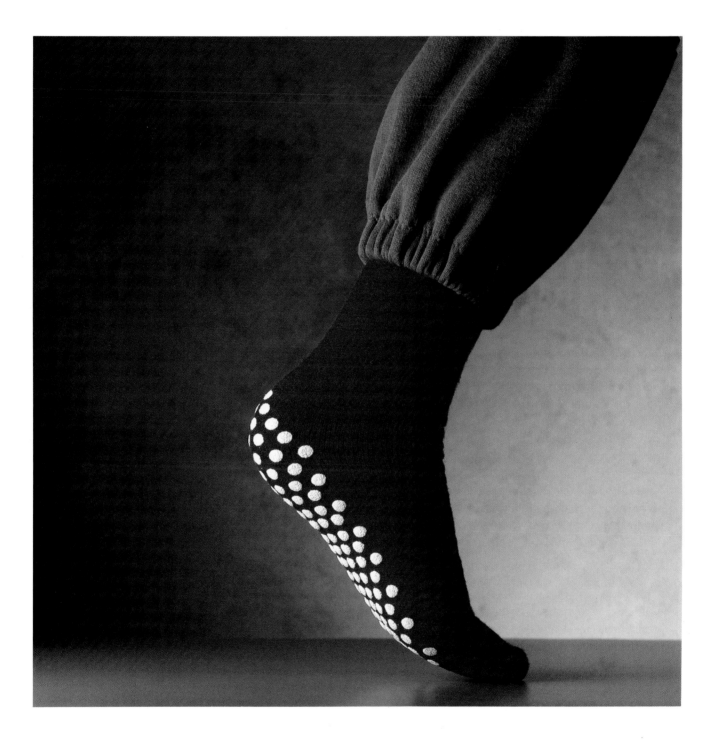

DETOURS, SIDE TRIPS, AND EXCURSIONS

TIM: There is tremendous pressure on a professional photographer to become more and more efficient in his approach to photography. In order to cope with this pressure for increasing production and efficiency, preplanning is essential. You save a great deal of time by having a comprehensive lighting approach in mind before you start shooting rather than relying on trial and error or unfocused effort.

But there are also dangers inherent in excessive dependence on preplanning. Often photographers develop formula lighting techniques to deal with certain recurring situations. Formula lighting is fine as a starting point, but following it slavishly leads to a mind-dulling sameness in the look of your photographs. For example, lighting by a formula can make all reflective objects begin to look very similar. The objects aren't, but the lighting is.

Formula lighting ignores the subtle nuances of the product, the different contexts in which the photography is used, and the variation in the goals for the final images. A car manufacturer doesn't produce one kind of car and expect it to meet every type of driving situation—or the needs and personality of every individual driver. Their customers would stop buying the car. And clients will stop buying your work for the same reasons.

It's imperative that the photographer be willing and ready to respond to the special needs of product and client. You have to be prepared to alter the lighting plan as needed—or even to abandon it altogether—to photograph your subject most effectively. Detours and deviations from the original plan can make your images truly unique and exciting.

Following where detours or side trips take you is easier on work you're doing for yourself than on work for clients where you have to deal with time constraints. Personal work, whether intended for your portfolio or for experimentation only, is the perfect opportunity to follow all the byways in your search for different and better lighting approaches. Fear of time-consuming dead ends should be less of a factor in your personal work. You can incorporate new techniques and applications discovered during personal projects into client jobs with a greater degree of predictability and less risk.

Deadline pressures, budgetary limits, and other related considerations make it difficult to make major, time-consuming changes on client jobs or to follow side roads without a relatively good chance you'll find a much better photograph. Still you've got to customize lighting for each photograph as much as possible within the constraints of a particular job You have to keep an open mind for possible deviations from your original lighting plan. Sometimes that involves a complete change of approach; other times it means only a shift in perspective, enhancing one part of the subject that didn't look particularly interesting initially or playing down a less desirable feature that leaped to the eye.

Above all, don't be afraid to take risks and make changes from your original plan. You can't foresee and plan for all of the variations and opportunities on each shoot, so accepting changes and handling detours is not only necessary, but essential in creating a compelling photograph.

JOE: I try to stay with my original lighting scheme as much as possible when I'm working on an assignment. Sometimes I stick with it a little too long, and I find myself caught up in a kind of creative tunnel vision. "Creative tunnel vision" occurs when I try to force my original lighting scheme to work—even when I can feel that it won't—and I find that I'm not being objective about the results.

When I realize what I'm doing, I stop everything and try to walk away from the set. Then I admit to myself that the lighting isn't working, isn't going to work, and I can't make it work. I try to avoid looking at any Polaroids or the set itself for several minutes, sometimes longer.

This helps to clear my mind so I can try to take a fresh approach to the lighting.

Then I go back to the set and turn off each light, one at a time, starting with the minor auxiliary lights and ending with the main light source. As I turn each light off, I pay careful attention to what changes and note what I like or don't like. Next I go back through all the Polaroids I've shot and look for something good that I did in one of the initial Polaroids that may have been lost as the lighting progressed. Many times, between turning off the lights and looking at earlier Polaroids, I can figure out what's not working with the lighting and begin to correct it.

I use Polaroids to make these corrections and try to make notes on what was happening for each one. I lay out all the Polaroids—early ones, ones that didn't work, and the new ones—and compare them. Using Polaroids to see where I've been and where I'm going is crucial to my working through a lighting problem.

Sometimes I go through all my usual steps in solving a lighting problem and I'm still not happy with the result. It may be the lighting or something else entirely. When this happens, I begin to experiment with a radical change in my approach to the shot. Sometimes I go back through the earliest Polaroids

again and suddenly notice an "accident" (a completely unplanned or unanticipated result) that happened or find an unusual or interesting effect that I really like. I focus in on that aspect and set up all over again for the shoot accordingly.

Other times I'll just walk around the subject on the set and look at what the same lights do from different angles. I may find something different that I really like and reset my camera and lights to that angle and begin all over again.

Of course, sometimes you can't find *anything* of interest to work with. Then the only thing left to do is—get out of there! If you can, sleep on it and start fresh the next day. When you can't leave it that long, even a short break from the studio can help. Once you've had a break you'll often trip over something you missed, find yourself moving in a completely different direction, or accept starting completely over from scratch. I guess the key to making the most of these "detours" is keeping an open mind and relying on your powers of observation to help find a lighting set that works to your satisfaction.

ALAN: I get a thrill from solving obscure problems in lighting. The twists and turns that defy logic are usually the most intriguing experiences. Many times a shoot doesn't turn out the way I've planned or

something better comes along. A photographer has to learn both good deductive and inductive thinking to deal with these twists and turns in the road—how to go around, over, or through the brick walls that pop up during a shoot.

Many times I find that something happens during a shoot that makes me stop and reexamine my direction. A harder light produces an unanticipated effect, a filter kills the subtlety I was striving for, color takes over and pushes the shot in a different direction. Or I realize that the client's layout isn't anywhere close to realistic or that the composition just doesn't send me anywhere.

When a shot plan isn't working I ask myself why it doesn't match the vision I had. Is it a weak idea? Is it the lighting, the composition, the color, the mood? I think we've got to be prepared to ask these questions if it's not working. I really believe that if we ask ourselves these questions and answer them honestly, we'll nearly always see why the shot isn't working.

Knowing when to let go of a good idea when a better one comes along is vital. It's important, though, to make sure it's producing a better result—one that does a better job of meeting the client's needs—and isn't just a technically better, or prettier, or more interesting but less relevant picture.

GREEN PEAS SHOT

WHAT I WANTED TO GET:

This image was part of a calendar that a local design firm planned to use in a direct mail self-promotion. The problem was photographing the peas to show roundness, dimension, and their bright "pea green" color. Capturing the green of peas was especially important because the designer wanted to pick up that same green for other graphic elements on the calendar spread. Green is particularly hard to get on film, so I tried to plan this shot even more carefully than usual.

HOW I GOT IT:

I began by lighting the peas with a 9" x 12" strip light from a low angle, the light positioned behind and slightly to the left of the set. This gave the peas a lot of dimension and helped to show some roundness. I also positioned a silver fill card opposite the strip light to fill in some of the shadows and help accent the water drops. This came out pretty much as I had planned.

When I looked at the initial Polaroids, however, I noticed that the color in the peas was not coming through (even when I allowed for that film's limited color range). That fresh pea color was an important part of the designer's idea so I absolutely had to come up with a way to get it. I solved my problem by taking a pale green gel and placing it over the main light source. This brought out the green color with all its brightness and saturation and made the shot a success.

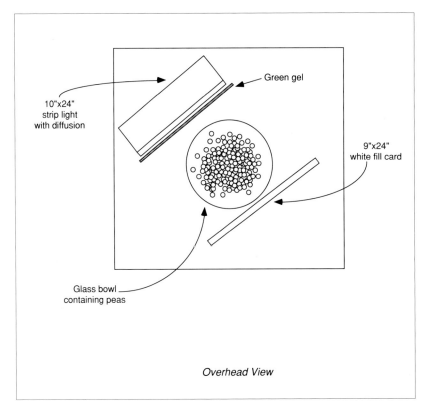

10"x24" strip light with diffusion

Green gel

9"x24" white fill card

Glass bowl containing peas

Overhead View

Client: Design Centre of Cincinnati
Photographer: Joe Braun
Art Director: Jim Makstaller
Design Studio: Design Centre of Cincinnati

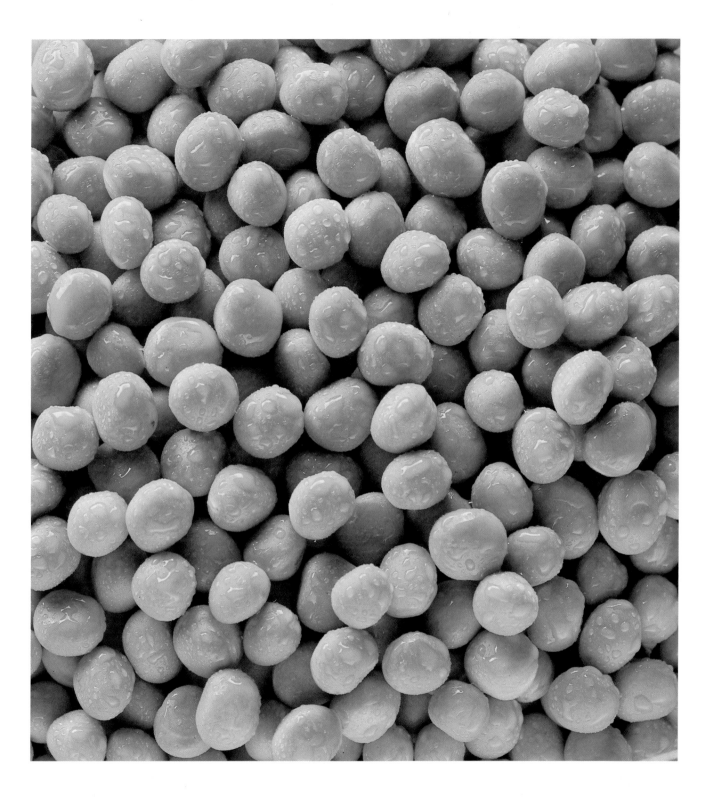

WOMAN IN RED HAT SHOT

WHAT I WANTED TO GET:

I agreed to shoot a portfolio piece for a fashion designer/clothing stylist friend about to move to New York. She wanted to have a piece that would not only show off her design and styling talents but that would also position her as being a slick, sophisticated professional. We began by using sharp lighting—in vogue at that time for fashion shots—combined with a high grain film—to make it stand out from typical shots of models. We felt that this would make the model and her clothes look sophisticated. We wanted to create a mood, not just an image, to enhance the look of the clothes.

HOW I GOT IT:

We experimented with a number of technical approaches: grainy film, pastel filter, and dark background, but none of these worked by itself. Each alone simply made it a technically better photograph. We finally decided the photo needed to be a mood piece with an air of mystery—something along the lines of the suggestive "slice of life" images now used in a lot of advertising.

I decided that a combination of techniques would give us the look the image needed, so I combined high grain film with a strong directional light to give it a very attractive texture. I added a pastel filter over the base to open up the heavy shadows caused by a sharp fall-off from my light source. The end result is the softly glowing photo that not only says "professional styling/

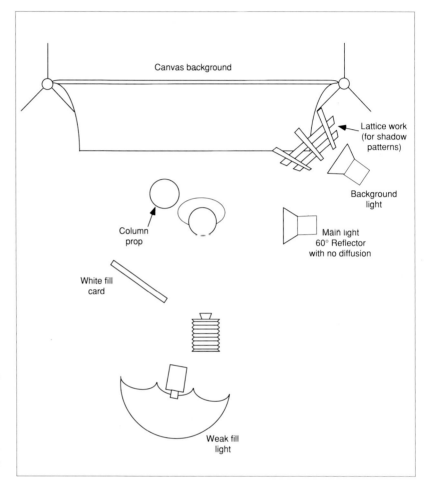

Canvas background

Lattice work (for shadow patterns)

Background light

Column prop

Main light 60° Reflector with no diffusion

White fill card

Weak fill light

advertising," but which actively draws the viewer into it.

Although it took time to work through all the various technical solutions, being open to a variety of possibilities and staying flexible during the shoot produced a better image than the original concept.

Client: Kulina Beatty
Photographer: Alan Brown
Model: Adrienne Delisse
Stylist: Katina Beatty
Make-up Stylist: Regina Mikonis

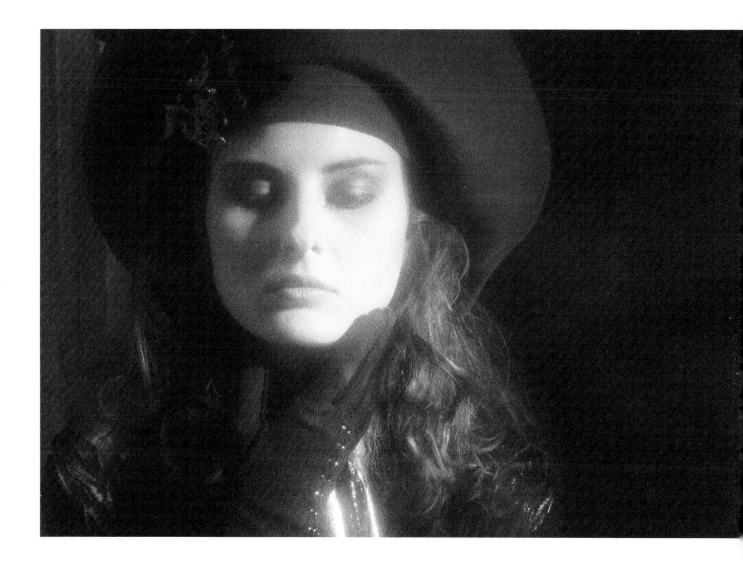

BASH INVITATION SHOT

WHAT I WANTED TO GET:

We wanted a photograph for the invitation to our annual studio party. Since we used the term "bash" to describe the party, I thought it would be appropriate to put the model in boxing gear to play up the double meaning in the word.

HOW I GOT IT:

We shot this first without the head-gear. I used a rectangular soft box as the main light, placed far enough to the right to illuminate only the right half of Diane's face. A fill board on the left bounced light back into the shadows but left a fairly high amount of contrast between the shadow and highlight side of her face. An Opalite with a grid spot was positioned above and behind Diane to highlight her hair and another Opalite was placed to the left and behind her to throw a bright spot on the left side of the background. This gave me an interesting image of an attractive woman in boxing gloves.

But it didn't quite fit the concept. Diane looked too good; we'd ended up with a Midwestern glamour girl who happened to be wearing boxing gloves. To enhance the play on "bash" and deflect some attention from Diane as a model, I decided to add the headgear. The lighting that had worked for the first version didn't work now. The headgear created some deep, dark shadows on her face.

I solved the problem by moving the main light slightly closer to the camera to shorten the shadows. The fill board was moved closer to bounce more light into the shadows and reduce the contrast of highlight to shadow. I also oriented her face more to the right to further reduce the effect of the shadows. The lighting on the gloves and her body, however, retains the dramatic look I had been striving for. I think the final image puts across the visual pun on the double meaning of bash in an exciting and dramatic way.

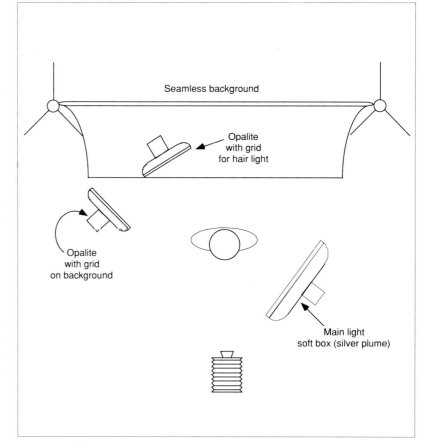

Seamless background

Opalite with grid for hair light

Opalite with grid on background

Main light soft box (silver plume)

Client: PhotoDesign
Photographer: Tim Grondin
Model: Diane B.
Hair & Make-up Stylist: Gina Mikonis

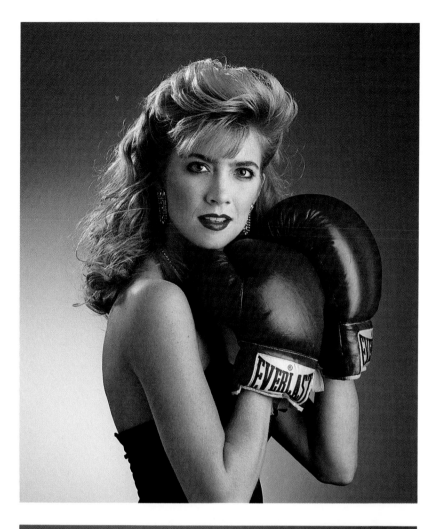

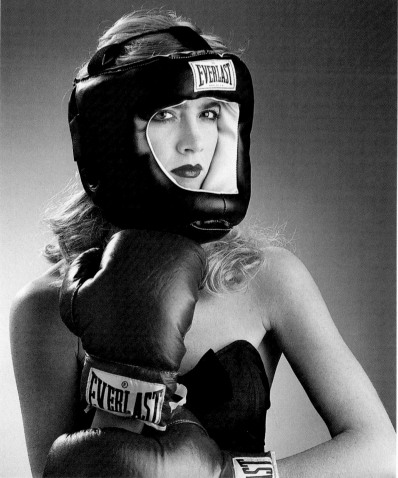

BLACK LACE IN OUTER SPACE SHOT

WHAT I WANTED TO GET:

I had arranged with a designer to do a series of self-promotional pieces that both he and our studio could use. Although we hadn't yet settled on the type pieces we would use, we decided to plan the images around rhyming phrases that we could match with a visual symbol. Not knowing how the image would be used made my job even harder. I didn't start with any mental picture—no format, no size, nothing. It's much harder to make a commitment to any approach when you don't know what it's intended for.

I started this shoot with no more definite concept than creating a visual to go along with the words "Black Lace in Outer Space." Because the phrase makes no sense—the words are only related by the rhyme—I felt the visual symbol needed to blend or juxtapose two unrelated images.

HOW I GOT IT:

The shot just evolved because there was no plan. I wandered around the set trying to find a literal and figurative point of view. I used two different cameras, one aimed at the set with the woman and the black lace, the other aimed at an illustration of stars on a black background. Then I combined both images on one piece of film by shooting one image and transferring the film to the other camera for the second image. I put a very directional light behind the model to create very heavy shadows on her front in order to make the trick work. We finally produced a nice image. In fact, we produced two. We used the one showing the model's face in the promotion, but I still prefer the one showing the model's back.

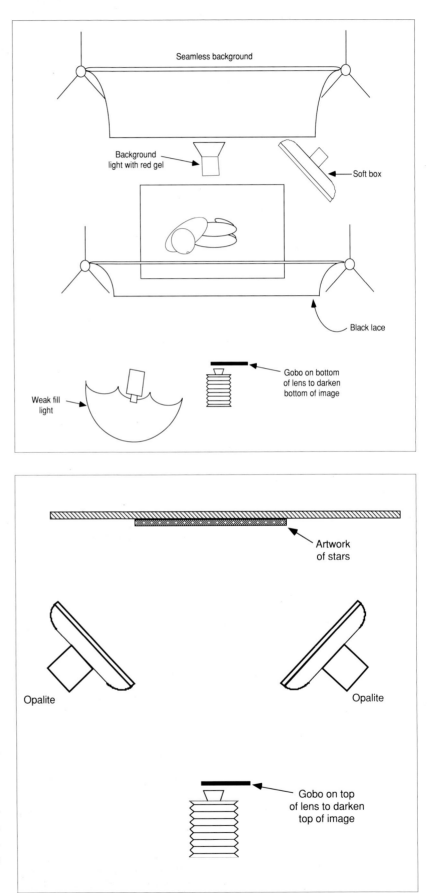

Seamless background

Background light with red gel

Soft box

Black lace

Weak fill light

Gobo on bottom of lens to darken bottom of image

Artwork of stars

Opalite

Opalite

Gobo on top of lens to darken top of image

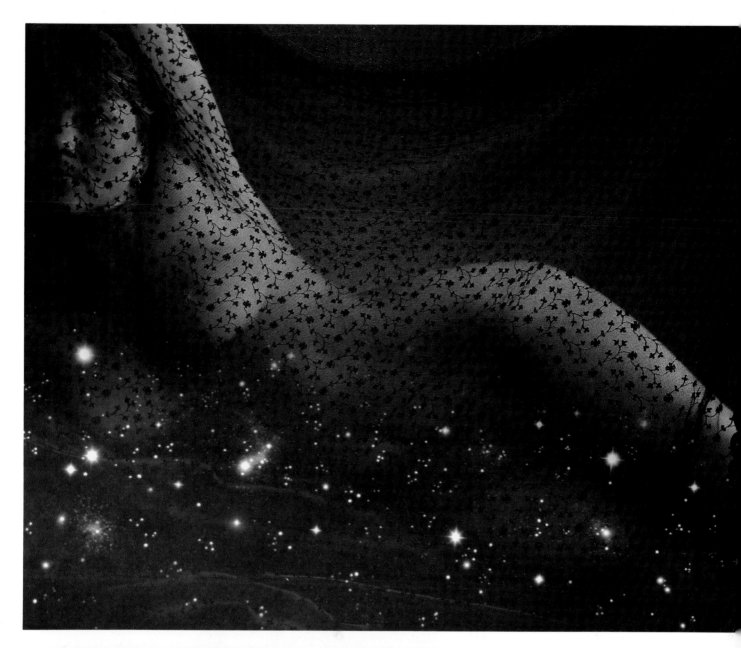

Client: PhotoDesign/
Design Centre of Cincinnati
Photographer: Alan Brown
Model: Susan Tarvin
Art Director: Jim Makstaller
Design Studio: Design Centre of Cincinnati

FOOD SHOWER SHOT

WHAT I WANTED TO GET:

Much of *Cincinnati Magazine*'s annual "Best and Worst" issue focuses on popular and unpopular food offered by local restaurants. The art directors, Tom Hawley and Nancy Pace, and I developed the idea of a food shower to graphically illustrate the concept of being inundated with food choices.

Shooting food and shooting suspended props are two of the more difficult situations photographers face. Separately, each situation is difficult; together—showing flying food—they're a nightmare no sane photographer would tackle.

HOW I GOT IT:

The flying food created a number of difficult lighting problems. The set was eight feet wide and ten feet high, and had to be lit fairly evenly from top to bottom and from side to side. The lighting had to work no matter what direction the model, Jane Franz, faced since we couldn't reposition it as she moved. The lighting also needed to leave fairly subdued shadows to prevent distracting multiple shadows from all the different items. Wrap-around lighting from large light sources seemed to be the answer.

Eliminating the shadow the umbrella cast on Jane's face proved to be a serious problem—because her face was significantly darker than the other elements in the photo, it wasn't the focus as it should

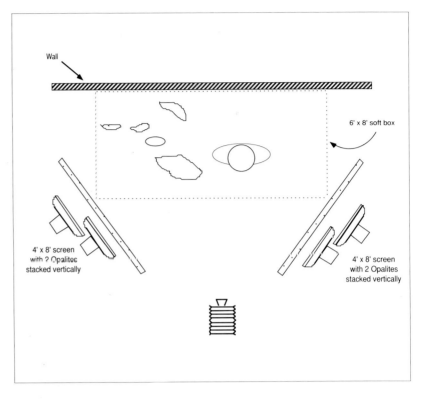

have been.

We solved the problem by changing the position of the lights behind the screen. We lowered them to direct more light under the umbrella and moved them closer to the screen to make each more directional and easier to adjust independently. With that additional flexibility we could get just the right amount of light under the umbrella without destroying the original feel of the lighting. We were able to do a shot with a very unusual concept by successfully solving technical lighting problems to create a striking image.

Client: *Cincinnati Magazine*
Photographer: Tim Grondin
Model: Jane Franz
Art Directors: Tom Hawley, Nancy Pace
Hair & Make-up Stylist: Gina Mikonis

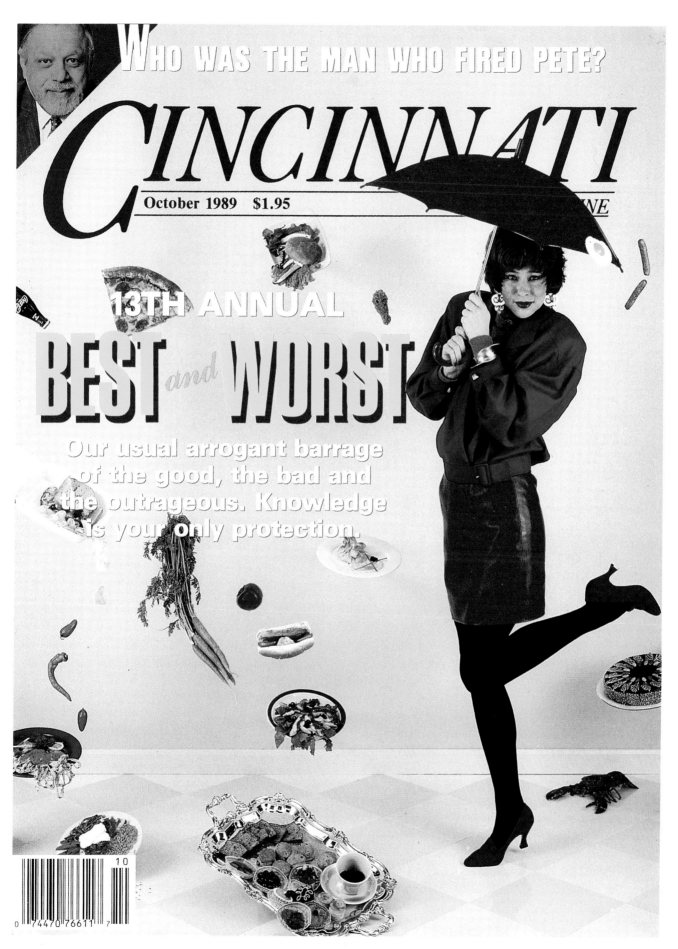

WHO WAS THE MAN WHO FIRED PETE?

CINCINNATI

October 1989 $1.95

ZINE

13TH ANNUAL

BEST _and_ WORST

Our usual arrogant barrage
of the good, the bad and
the outrageous. Knowledge
is your only protection.

41

ADDY SHOWBOOK POSTER SHOT

Flash head with 60° reflector and 35° grid spot

4'x8' fill board set 2' to camera right

8x10 Camera with 300mm lens

4'x8' wall flat with pay phone mounted in center

4'x4' silver fill card below and slightly to the front of set

WHAT I WANTED TO GET:

The committee for the 1983 Cincinnati Addy Awards Showbook wanted a poster to send to potential advertisers, primarily ad agencies, to persuade them to place an ad in (and help pay for) the cost of producing the book. The concept for the poster was to suggest that a phone call to a client might soon be forgotten but an ad in the Addy Awards Showbook, surrounded by exciting work, would be remembered. The layout showed a pay telephone surrounded by bits of paper and business cards with telephone numbers scribbled on them

with the headline "When you call on your clients, are they getting the message?" In order to reinforce the message, the art director wanted the set to look like the phone was in the kind of out-of-the-way place that you quickly forget.

HOW I GOT IT:

At first I approached lighting the set in the standard "let's flatter the product" manner. I tried to light the telephone, tattered messages, and graffiti just as I would if this were an ad selling telephones. I used a broad, soft light source and a couple of white fill cards. The pay

phone looked pretty good. In fact, it looked *too* good to work for the concept. So I backed off to rethink my approach. This time I put a direct 60-degree flash head almost directly over the top of the pay phone. Then I put a narrow 35-degree grid spot attachment on the spotlight and projected the beam down so the set looked like it was stuck in a dingy back room, out of the way and forgotten.

Client: Advertising Club of Cincinnati
Photographer: Joe Braun
Art Director: Bill Shirk

42

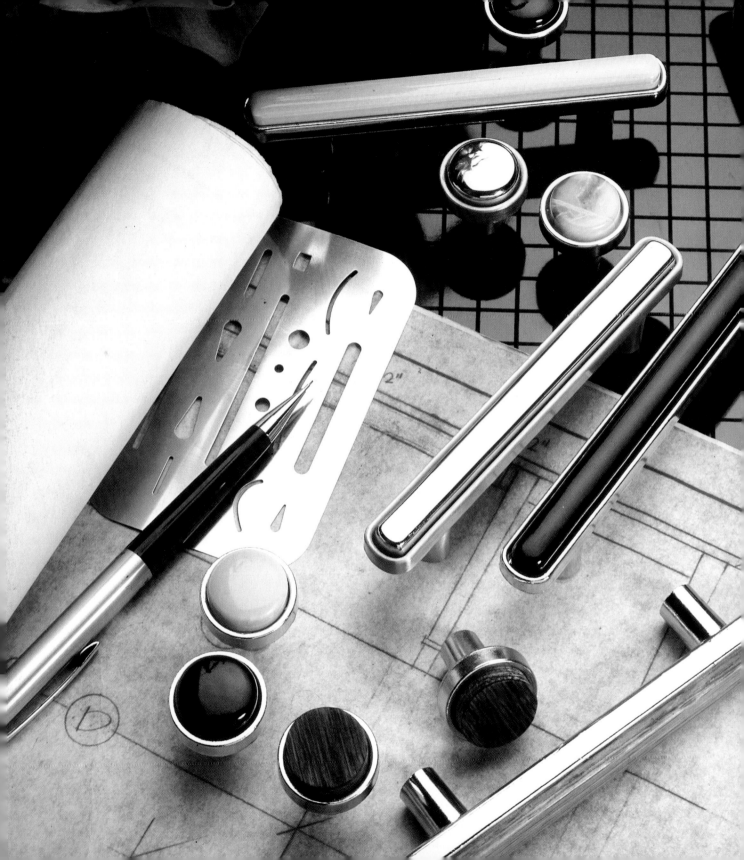

Highlights

In this chapter we'll look at ways we create with and control highlights. Highlights can add excitement to an image and help call attention to a product's special features. You'll see how we've worked with a variety of surfaces: metal, plastic, glass, chrome, and even lightbulbs! We'll also be talking about controlling reflections since these are often serious problems in working with shiny (and therefore reflective) materials.

This image of a pen was one of a series of five shots to be used as covers for F&W Publications' 1988 Market books. Each cover would feature one "tool" that the reader of the book would use—a brush for *Artist's Market*, a section of a camera lens for *Photographer's Market*, for example. Each item would also symbolize the type of person who would buy the book. The pen would be used for *Poet's Market*, and needed to convey the essence of poetry in a single, dramatic image. I was interested in creating a very idealized image of a pen but, rather than just do slick, pretty highlights on it, I wanted to make it look fairly believable. It should suggest it was a pen someone really owned and loved. So I chose to create shadow areas that would break through the highlights and give it shape, give it more dimension. And I think all of this gave it more impact.

The first mistake most people make when they light metal is trying to get the whole surface to be an even brightness. But that doesn't really show that the surface is metallic. What makes something look metallic is the lights and the darks, the brighter areas and the darker areas, so that you get a sense of the glistening, shiny nature of the metal.

Lighting metal is a very difficult problem because metal sees anything you show it. Whether you're lighting large or small metallic objects, basically the concept of lighting them is the same. You either start with lighting up the whole object with some form of white and then create shadow areas or you start with black and add highlights.

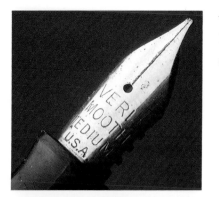

◄ In these pictures you'll be able to follow the results of small, progressive changes I made in the lighting setup. Here the light is in close, covering as much of the surface as possible.

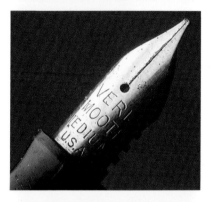

◄ I backed the light off a bit from the original position and moved it a bit to the left. You can see the impact on the shadow—it broke on the I in the last Polaroid, now it breaks on the R. This changes the shape of the nib and gives the edges slightly less definition than before.

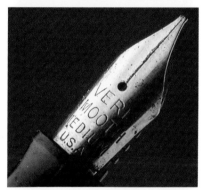

◄ Now I've added a white board to the previous setup. This gives the nib a little more dimension, a little more motion.

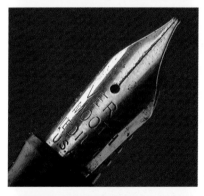

◄ Here I've taped a black card to the light bank to create a shadow on the left. This creates bands of dark on the metallic surface, setting a pattern of dark and light.

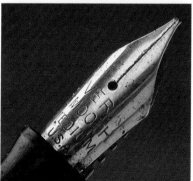

◄ Here I've added a yellow card on the right to the setup in #4. This adds back a bit of color to the nib. If you were to use only white boards, you would tend to flavor the color of the pen nib from a golden color to a burned-out, whitish-looking gold. To really see the difference, look back now at the first one.

▼ Black paper interrupts the shape of the highlights.

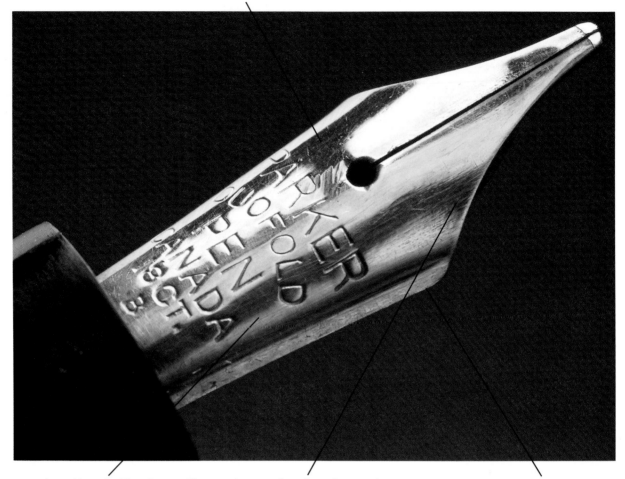

▲ Another gold metallic fill card gives additional flavor to the color.

▲ Playing up the nicks on the pen enhances the natural texture and quality of the gold.

▲ This gold metallic fill card dropped back changes the intensity of light on this strip.

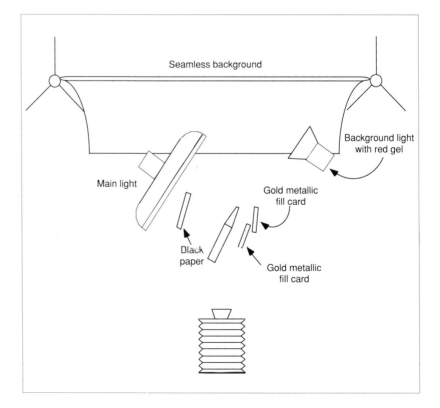

Seamless background

Background light with red gel

Main light

Gold metallic fill card

Black paper

Gold metallic fill card

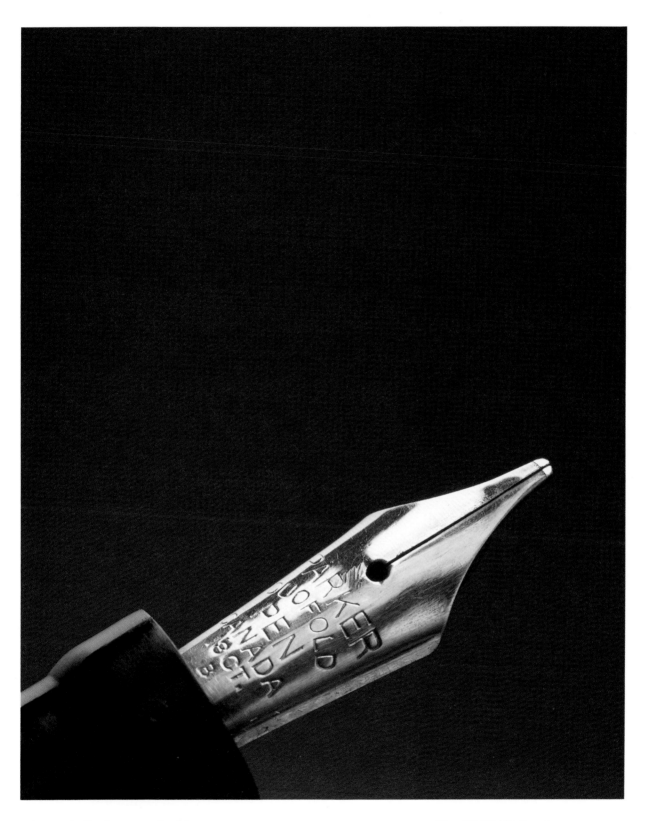

▲ I was excited by the amount of activity we created in a small subject. We usually work on much bigger subjects, which are easier to light because we have more room to maneuver.

Client: F&W Publications, Inc.
Photographer: Alan Brown
Art Directors: Carol Buchanan, David Lewis

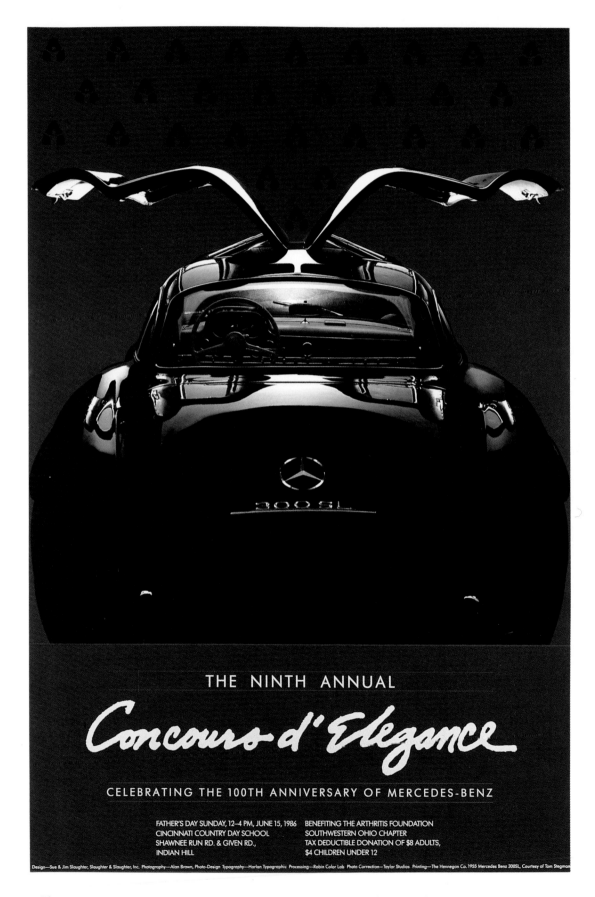

THE NINTH ANNUAL

Concours d'Elegance

CELEBRATING THE 100TH ANNIVERSARY OF MERCEDES-BENZ

FATHER'S DAY SUNDAY, 12–4 PM, JUNE 15, 1986 BENEFITING THE ARTHRITIS FOUNDATION
CINCINNATI COUNTRY DAY SCHOOL SOUTHWESTERN OHIO CHAPTER
SHAWNEE RUN RD. & GIVEN RD., TAX DEDUCTIBLE DONATION OF $8 ADULTS,
INDIAN HILL $4 CHILDREN UNDER 12

Design—Sue & Jim Slaughter, Slaughter & Slaughter, Inc. Photography—Alan Brown, Photo-Design Typography—Harlan Typographic Processing—Robin Color Lab Photo Correction—Taylor Studios Printing—The Hennegan Co. 1955 Mercedes Benz 300SL, Courtesy of Tom Stegman

This assignment was a shot of a burgundy Mercedes gullwing car for the Concours d'Elegance Classic Car show for the annual commemorative poster. The car for the poster is chosen by a committee, and then we're called in to work on the shot.

Cars pose an interesting problem. They are like mirrors in that they "see" anything they are shown. Lighting a car is a long, tedious process of planning each and every highlight and shadow, and then creating them. These problems are compounded by the large size of cars. In order to make a successful car shot, we have to be aware of the very idealized visual memories people have of what cars look like. Then we have to create that idealized memory with the play of tone and texture, the patterns of lights and darks, the flow of the tones—and that's why we're so absorbed with highlights and shadows.

Client: The Arthritis Foundation
Photographers: Alan Brown & Joe Braun
Car Provided by Tony Stegman
Art Directors: Jim & Sue Slaughter
Design Studio: Slaughter & Slaughter

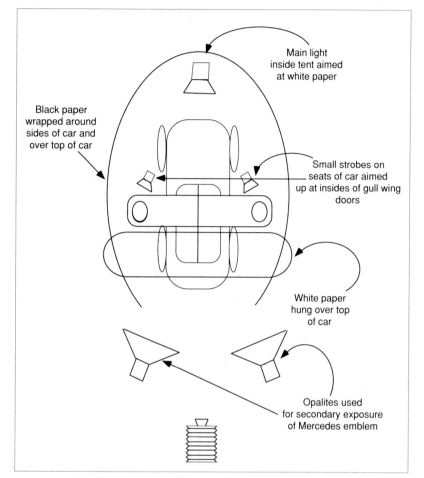

Main light inside tent aimed at white paper

Black paper wrapped around sides of car and over top of car

Small strobes on seats of car aimed up at insides of gull wing doors

White paper hung over top of car

Opalites used for secondary exposure of Mercedes emblem

▲ We decided to create a tent (a structure of material used to envelop a product and reflect a continuous, uninterrupted surface into the product) of black paper around the car to keep it from reflecting the garage in which we had to shoot the car. We set up light stands, background paper supports, and whatever we could get our hands on to run seamless paper up on either side of the car to block off as much as we could. We also stretched paper over the top of the car. Our approach was to create one broad white shadow going across the car to give it its shape. We stretched white paper under the black paper going across the top of the car to create the highlight. The black tent behind the white paper would make the highlight stand out.

▶ We started out lighting the car with the premise that we were shooting a burgundy-colored car—after all, that *was* its color. The car was very round and "saw" the entire garage reflected in it. We saw the ceiling, the windows, and the cinderblock walls all as reflections in the car. And that, of course, is why we went with the tent.

We put a small hand-held strobe on each of the car seats aimed up at the inside of the doors. This was done to pick up details on the insides of the doors. One light at the front of the car was aimed up at the white paper to create the bright highlight. We then put a light on either side of the car aimed at the black paper to bring up the ambient light level and bring out the burgundy color.

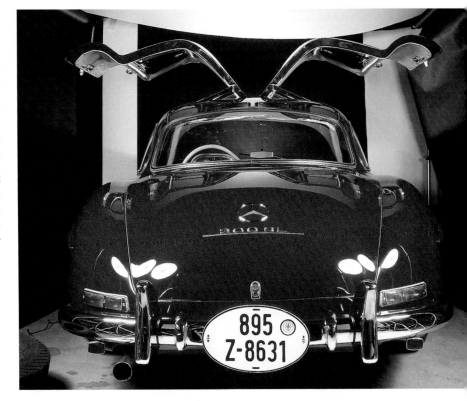

▶ After shooting some film we shut down the side lights and noticed that the car was far more interesting looking when the highlight popped out in relief against a silhouetted car. The burgundy color disappeared and the car looked black because the car was "seeing" only the black paper. The highlight across the top of the car really accented nicely the shape of the car.

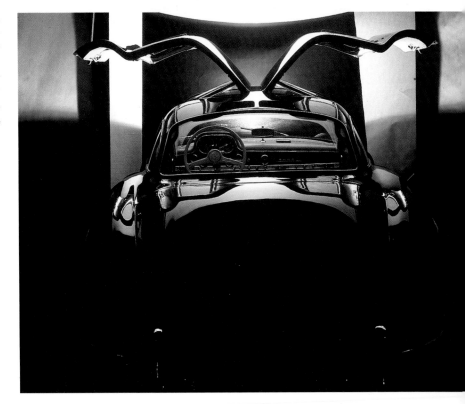

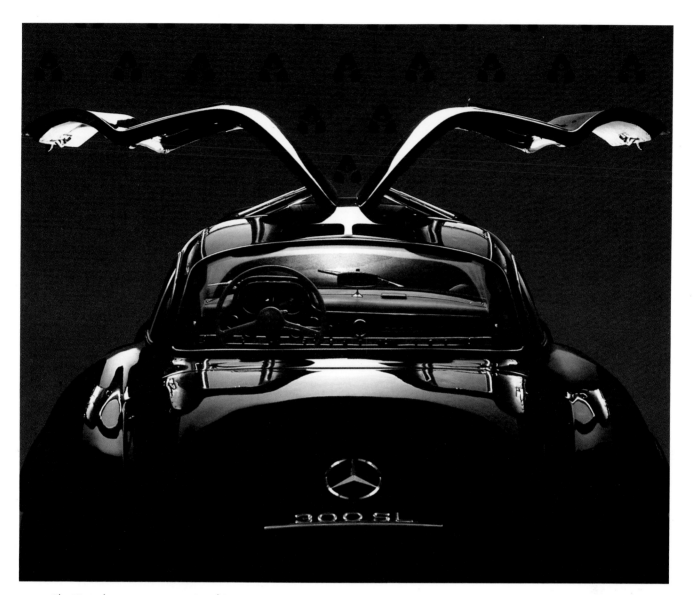

▲ The Mercedes ornament was stripped in from our original lighting as it, too, disappeared with only lighting for the highlight across the top of the car.

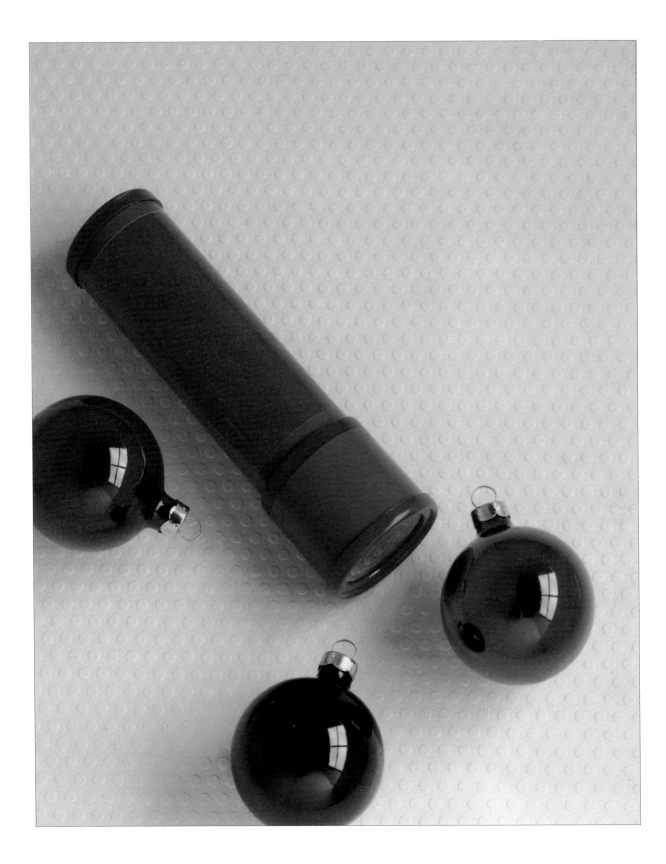

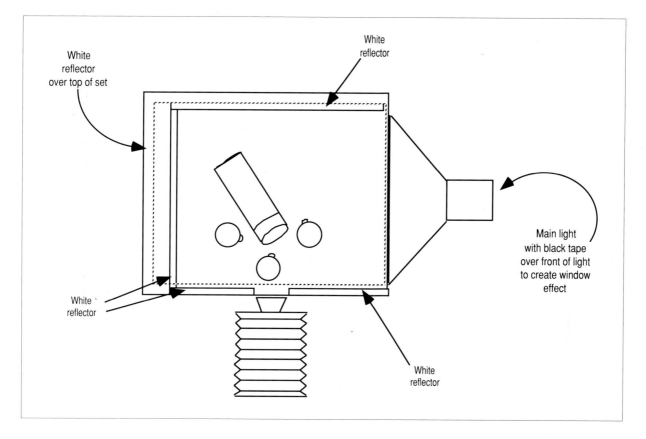

White
reflector
over top of set

White
reflector

White
reflector

Main light
with black tape
over front of light
to create window
effect

White
reflector

This was to be the cover for a calendar. Everything works together to say "Christmas": the ornaments, the kaleidoscope (by its colors), and even the white background give it that seasonal feeling. The textured background was chosen to give the picture more interest and to enhance the Christmas theme by suggesting (very slightly and indirectly) a feeling of snow. The idea is to suggest the emotions and activities that go with the holiday.

The light, although directional, is very soft. You have to look twice to figure out exactly where it's coming from. It bathes all the objects in a warm glow—like the holiday. The viewer will feel drawn into the photo by the warm, cozy feeling it suggests.

The lighting was dictated by the technical considerations involved. There are two main elements—the textured background, which consists of raised white disks on a background, and the props, the three ornaments, and the kaleidoscope covered with a glossy coated paper. This paper makes the kaleidoscope slightly less reflective than the three ornaments, but still reflective enough for that to be a concern. In fact, you can see the ball at the far left reflected in the side of the kaleidoscope. The textured background and the reflective props create two completely separate sets of lighting problems and even tend to work against each other somewhat.

▲ I had to look at what the lighting did to my props. The ornaments are extremely reflective, mirror-like; if you look closely, you can see the entire set in there. You could even say there are *no* lighting "secrets" in this case, you can see everything we used reflected in those ornaments.

By necessity there's always going to be a black hole where the camera is. There will also be the reflection of the other props, for example, the ring just inside the rim of the ornaments is the background being reflected up into the ornament. The reflection of the other ornaments and the kaleidoscope into each ornament will also create a dark area, so you're starting out with a certain number of dark areas to begin with.

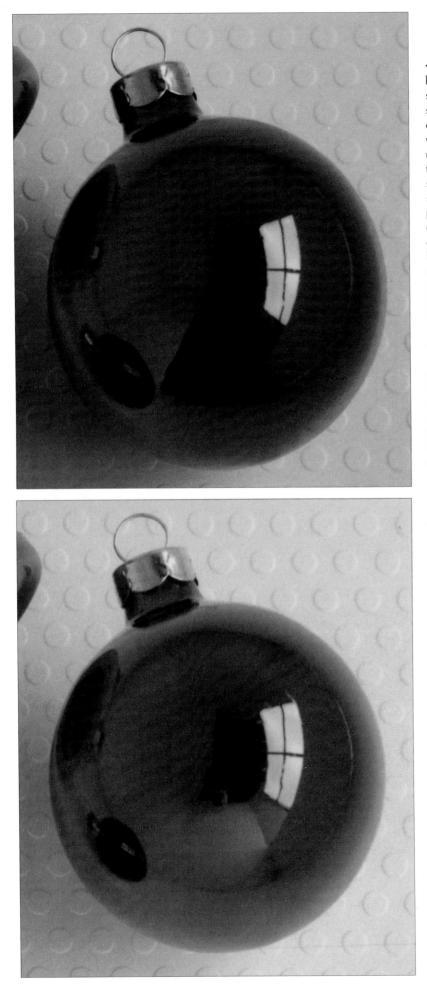

◄ The light source for the reflective objects had to be somewhat diffused, unlike the light source for the background which had to be strongly directional. A point light source would create small, very intense highlights which would tend to become very distracting. I needed broader, softer highlights spread over the objects. To achieve this effect, I used a single, large—36-inch-square softbox—light source, placed quite close to the table. It was placed very low to give it a dimensional quality that would bring out the texture of the objects and background, but still leave highlights and distinct shadows despite the size of the light. You can see this in the final image, where the highlight on each ornament is relatively large and the one on the rim of the kaleidoscope is much broader and softer than the hard edged bright line a small light source would give you.

The light source was so apparent that I wanted to disguise it a bit. We added crossing lines over the light source by placing black tape over the light's surface to create the appearance of a window. This created the illusion of objects lying in a room lit by natural light rather props sitting in a photographer's studio.

◄ Highly reflective objects in a dark environment tend to look black rather than their true colors. You need to reflect white into the objects to show that color. So I constructed a light room, as opposed to a light tent, with white cards butted together reflecting the light from the main light source. The seams had to be very clean and small so they would be difficult to see. At the same time, creating a "room" around the props enhances the viewer's sense of reality—it makes it seem that the props were shot in a "real" room, not merely in an abstract studio set.

The white boards also got rid of the large black holes (especially the one in the center of each ornament) created by the reflections from all the other props. In this case, of course, I had to create quite a few light areas to counteract all the black areas I started out with—the hole from the camera and the various reflections.

KALEIDOSCOPE

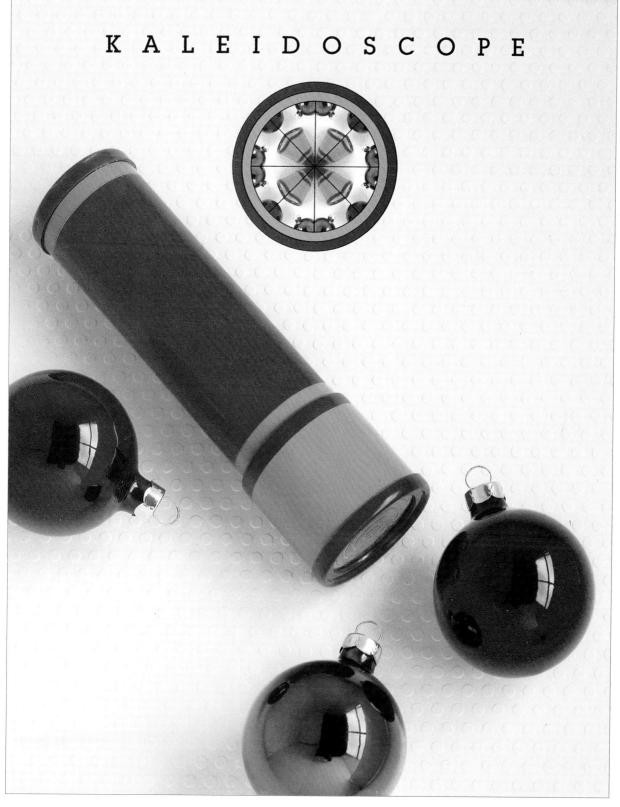

▲ We ended up with a very strongly directional but very soft light source. The shadows around each of the ornaments and the kaleidoscope are very soft-edged and open—due to bouncing a lot of that directional light source back in with the fill boards.

The overall feel works with the holiday, Christmas theme of the photograph. A harder, crisper lighting might have been too harsh for this type of situation. We've managed to solve all the technical problems involved in this shot while retaining the mood desired.

Client: Color Systems, Inc.
Photographer: Tim Grondin
Art Director: Mike Hensley
Agency: Business & Industrial Marketers, Inc.

HIGHLIGHTS: MORE THAN ONE LEVEL OF BRIGHTNESS

This image was shot for an ad for cabinet hardware targeted for builders and designers. The props and background were set by the interests of the target audience. The product manager and I wanted to communicate a relatively slick, technical feeling to best appeal to this group. The lighting, therefore, needed to be clean and crisp and show the nature of the products clearly. The color, texture, and materials of each product had to be easily discernible.

Overall the lighting is center-weighted. The intensity fades out to the left and above that area. We did this to allow type to be dropped out of the dark background. The blueprint, the highly reflective handles, the compass, and the template provide bright areas, but overall the blueprint is duller and the light level also fades toward the corners.

Client: Nutone/Ajax
Photographer: Tim Grondin
Art Director: Dick Binzer

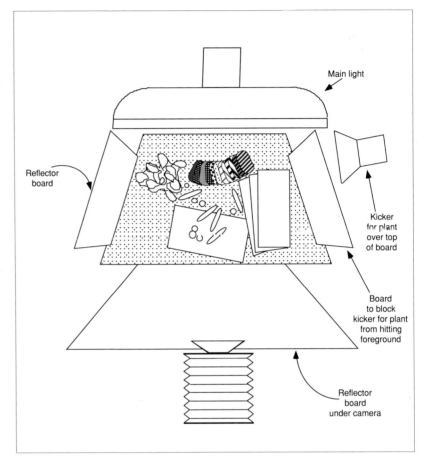

Main light

Reflector board

Kicker for plant over top of board

Board to block kicker for plant from hitting foreground

Reflector board under camera

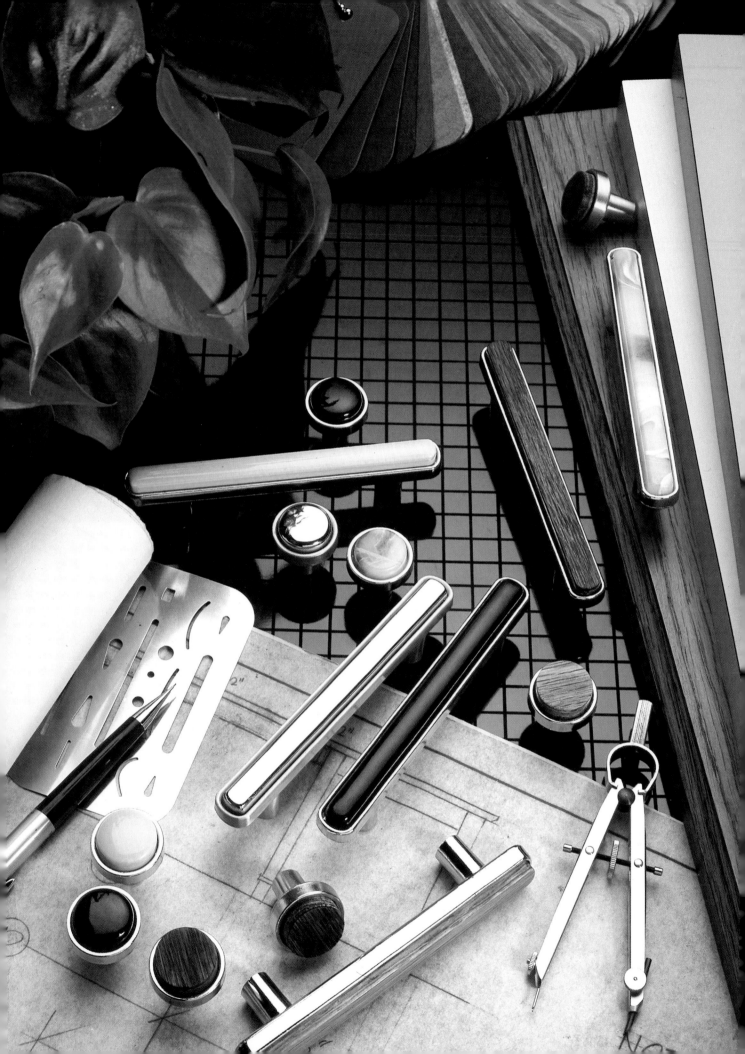

▶ The broad, diffuse light source on the black laminate, grid background is brightest in the area where three of the handles converge. I accomplished this by using a softbox with the lamp head in the spotted position. The lamp head is pushed forward toward the diffusing screen, leaving the center of the screen brighter than the edges. Not all softboxes have this feature, but most have some center-to-edge fall-off of light. Sometimes you can remove an internal diffuser to increase this center-to-edge fall-off. Although we often just automatically think softboxes with even edge-to-edge illumination are preferable, in this case—and some others—center brightness can greatly enhance the lighting.

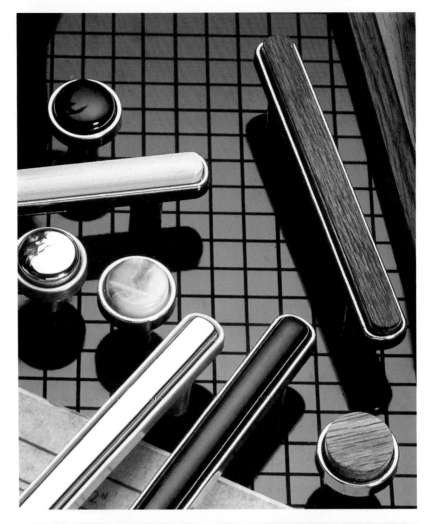

▶ Even the plant is illuminated by highlights. The leaves are a very glossy green, lit by a light to the right of the camera. The light has a 65-degree reflector and a grid spot to narrow the beam. This light is aimed so it illuminates only the plant. Green plants are notorious for soaking up light and often need auxiliary lighting to help balance them with the rest of the photograph.

The highlight on the template is bright, but it's slightly darker than the pen tip because of its dull finish.

The brightest highlights are on the two polished chrome handles, the polished chrome knob, and the pen point. These areas are almost pure white, while other highlights are darker.

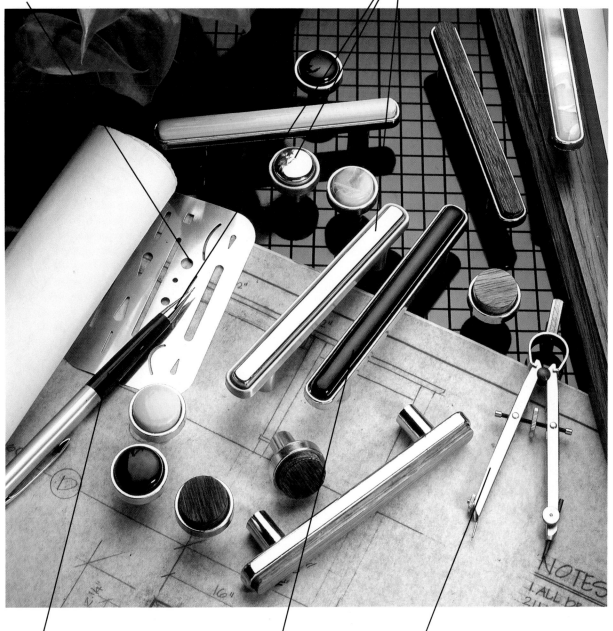

The black highlights on the pen are a medium gray tone.

The black handle has a darker highlight than most of the other objects.

The compass is highly reflective but slightly more yellow and not as bright as the chrome handle next to it.

▲ This photograph is overflowing with highlights. Many of the elements are highly reflective, and the lighting must both bring out and control the highlights in order to show the nature of the finishes and to create interest. The range of materials to be shot and the various ways they reflect light made this an especially complex problem.

I shot this photo for a color separator, Color Systems. The art director wanted to have red, blue, and yellow lightbulbs in the shot, so we used a field of identical lightbulbs but illuminated only the three colored ones. The idea was to show these three standing out from the rest of the field; only they are magically "brought to life" in brilliant color. This suggests what Color Systems can do for their customers. They can take a bunch of black, lifeless forms and make these brilliant colors pop out. So, it's vital that the red-, blue-, and yellow-colored lightbulbs be extremely brilliant and dominate the whole image. This means using a very neutral but dark background to enhance the colors and really make them pop.

An important element is not what the light reveals but what the light conceals. The photograph had to suggest a sense of infinity, of all those dark bulbs stretching away into nothingness. The eye should be drawn first to the three lighted bulbs, then roam over the rest of the field to pick up the repetitious rows of darkened bulbs, before returning to the center of interest. The viewer needs enough information to know they are bulbs, but not so much as to be distracted by them. Another important element is the symmetry and balance inherent in the composition. To enhance the impact of the colored bulbs, all the background elements had to be equal in importance—and so did the lighting within the colored bulbs themselves.

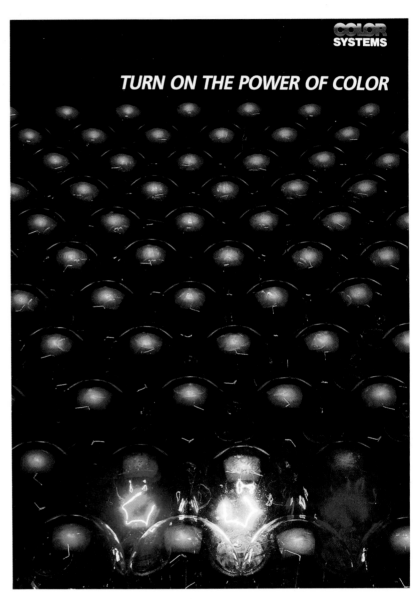

TURN ON THE POWER OF COLOR

COLOR SYSTEMS

Client: Color Systems, Inc.
Photographer: Tim Grondin
Art Director: Mike Hensley
Agency: Business & Industrial Marketers, Inc.

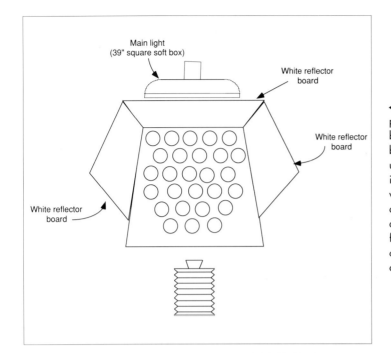

Main light
(39" square soft box)

White reflector
board

White reflector
board

White reflector
board

◀ The lightbulbs were arranged on a board painted flat (non-reflective) black. The colored bulbs were wired through holes drilled in the board while the rest of the bulbs were propped up with clay. I used a single light source, a 39-inch-square softbox, over the top of the set with two fill boards on the sides opposite each other, and another fill board behind and above the bulbs. I used two exposures: a flash from the top light with the colored lightbulbs out followed by a long exposure with only the colored lights on.

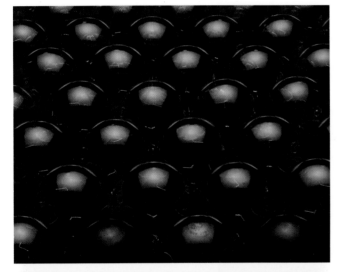

◀ First Exposure

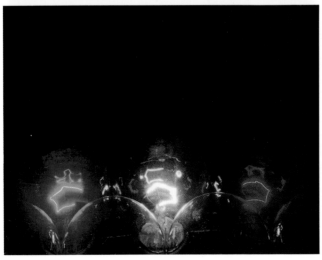

◀ Second Exposure

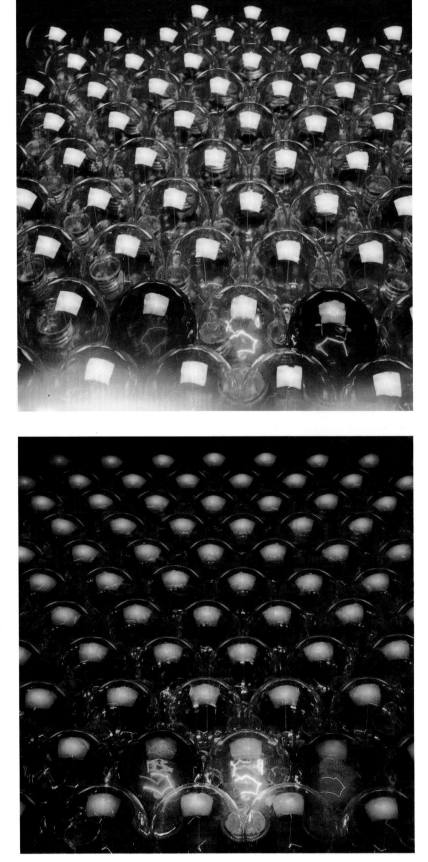

◀ The initial Polaroid revealed a number of big problems. The softbox flash was far too bright; the filaments within each bulb, and even the bases of the bulbs, were clearly visible, making the background overly busy. The highlight itself was so bright it was distracting. The pattern of highlights overwhelmed the colored bulbs.

◀ Here, I've made three changes from the last Polaroid. First, we wrapped the bulb bases in black tape to make them disappear against the black background. Second, the top light was powered down significantly, leaving hazy gray-white highlights in place of the bright, burned-up highlights. And third, I lowered the light closer to the set, broadening the highlights and changing the shapes from square to an oblong, softly curving one. The three highlights from the fill boards delineating the rounded top edge of each bulb are also more clearly visible.

But what about the distracting reflections of each colored bulb in the others? Cleaning up the background bulbs has made these reflections more apparent. They're spoiling the overall effect of colors on a black background.

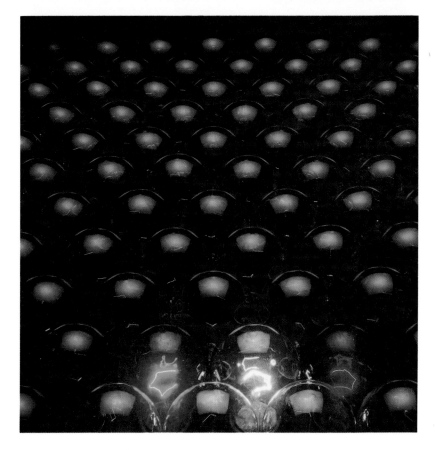

◀ After the overall flash, I draped a black velour cloth over the darkened bulbs to prevent the reflections of the colored lights. Since the cloth was only in place during the colored light exposure, the highlights are still there, but the distracting colored reflections are gone.

Now for the first time, the colored bulbs take center stage. All the distracting detail and reflections in the background have been cleaned up. But something still isn't quite right. It's now clear that the colored lights themselves are out of balance. The yellow light is brightest, with the red and the blue significantly darker.

◀ By putting each bulb on a separate switch, I was able to control each of their exposures independently. For this Polaroid, the yellow light was given an eight-second exposure, the red light got twelve seconds, and the blue got a forty-eight-second exposure. The colored bulbs are in much better balance, giving a similar intensity to the three different colors.

TECHNICAL CONSIDERATIONS VS. IMPACT

A beer bottle nestled in a bed of ice, beaded up with droplets of condensation, and ready to cool a parched throat can be a compelling image. To translate that image from the mind to a photograph is the challenge. And since this photograph will be used on packaging (a six-pack), it must quickly and convincingly catch the buyer's attention.

As often happens in the world of advertising photography, all is not as it seems in this photograph. Real ice would hardly last long enough to let me focus the camera, let alone survive the heat of the lights. So I substituted acrylic ice cubes, individually handcarved at $30 to $40 per cube. And, of course, the bottle wouldn't stay cold enough to show condensation after sitting under the lights while I shot. So I sprayed on the beads of condensation just prior to exposing the last test Polaroid. Aside from these helpful tricks, however, I'll use the lighting to bring my image to life.

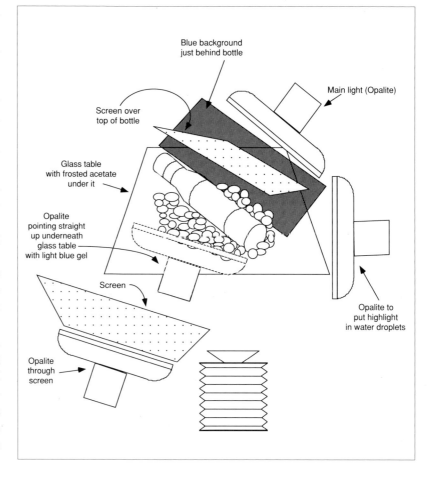

Blue background just behind bottle

Main light (Opalite)

Screen over top of bottle

Glass table with frosted acetate under it

Opalite pointing straight up underneath glass table with light blue gel

Screen

Opalite to put highlight in water droplets

Opalite through screen

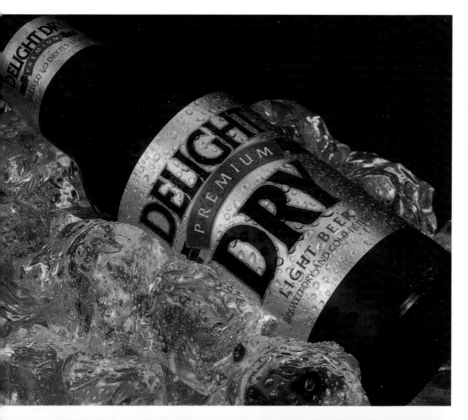

◀ Since the acrylic cubes are almost transparent, I had to backlight them so they wouldn't go too dark. The beer bottle is also very dark and would photograph black without a good bit of backlighting. I taped a sheet of frosted acetate under a piece of glass for diffusion and placed them under the acrylic cubes and the bottle. This shows the final bottle lighting without any underlighting. The cubes are almost black except for a few bright highlights.

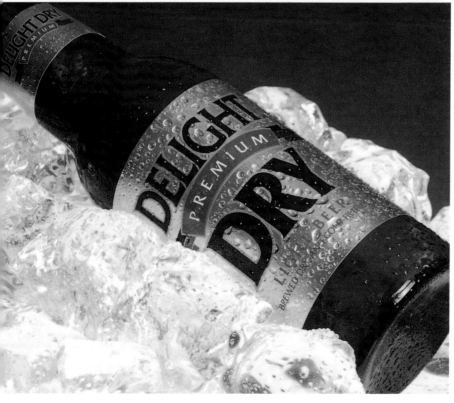

◀ Now I've illuminated the cubes and put only a work light on the bottle. You can see the cubes have come to life while the bottle has become a deep, rich brown. I also placed a very light blue gel over the light that backlights the cubes. It is barely perceptible, but it gives the cubes a slightly blue glow, psychologically enhancing their "cool" feel and differentiating them from the neutral colors in the label.

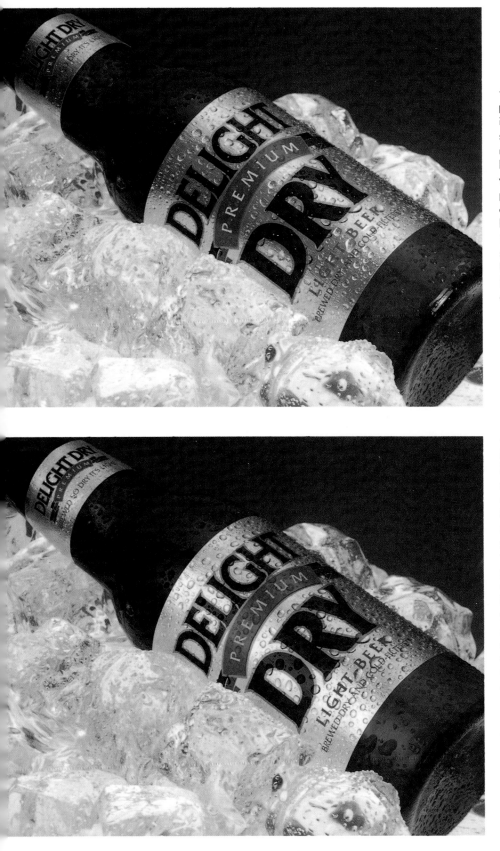

◀ The label is made of reflective foil with a pattern of tiny grooves that are meant to give it the appearance of being made out of stainless steel. The label has to be lit so it's very readable, but I can't let it get so bright that I lose the definition in the grooves and in the water droplets I'll add later. I used a light placed above the bottle with a small screen diffusing it to create the highlight you see here. The screen effectively changes an 18^1/$_2$-inch light source into a 24" x 36" light source that causes the softer, broader, longer highlight you see here. Despite the bright highlight, the intensity of the light is still low enough that the grooves can easily be seen.

◀ The highlight, though nice by itself, is too bright for the rest of the label. The alternating light and dark bands are dramatic, but they make the label more difficult to read. Since shoppers don't take time to study carefully all the labels on the thousands of packages confronting them on the store's shelves, readability is *extremely* important. The words "Delight" and "Dry" must leap off the shelf. I put another 24" x 36" screen to the left of the camera, slightly above lens level with a light behind given 50 percent more power than the top light. This creates a highlight similar in shape to the first, but brighter. (But the grooves and droplets will still show up clearly within the highlight!) The result is two bands of brightness—one only a half-stop brighter than the other—with darker bands on either side of each highlight. Now I've got a very readable label with the look of stainless steel, and I've shown the bottle's roundness.

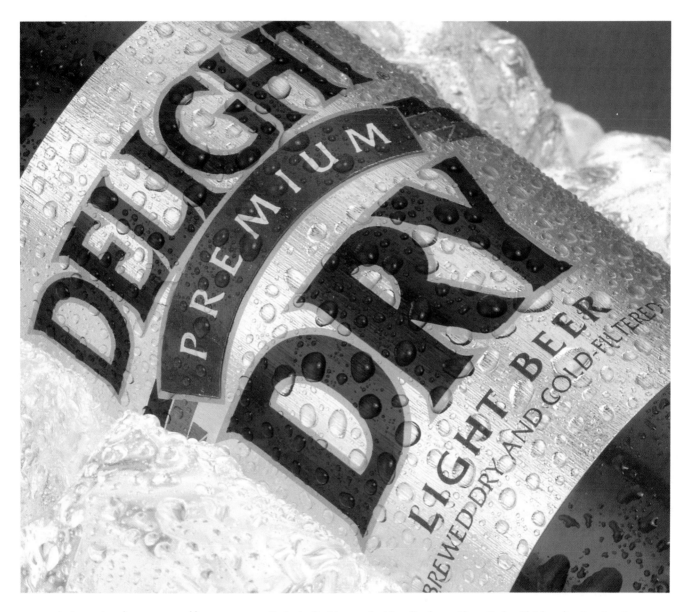

▲ An interesting change occurred between Polaroids #3 and #4. I turned off the work light focused on the bottle while I set the final lighting. This light, with an 18-inch reflector, had been placed high and to the right of the camera. Since the light was out of the angle for any direct reflection in the label, I didn't think turning the light off would have any effect. But I felt there was something missing in Polaroid #4. Closer inspection of the two Polaroids revealed that each water droplet on the label in #3 had a small, bright highlight—it's easiest to see if you look at the dark lettering areas. I decided to turn the light back on to give the droplets that bit of extra sparkle in the final image. (Incidentally, the water droplets are real water. It beaded up better on the label than any other formulation.)

Knowing how a photograph will be used is an important consideration because you can make lighting decisions based on the client's and the project's special needs. In this case I had to communicate a cold, icy effect while keeping the lettering readable and capturing the stainless steel quality of the label. This meant balancing the client's technical needs without losing the overall feeling to be communicated and the desired impact on the viewer. This image was cropped as you see here when it was used on the package.

Client: Hudepohl-Schoenling Brewing Co.
Photographer: Tim Grondin
Art Director: Ray Perszyk
Agency: Libby, Perszyk, Kathman

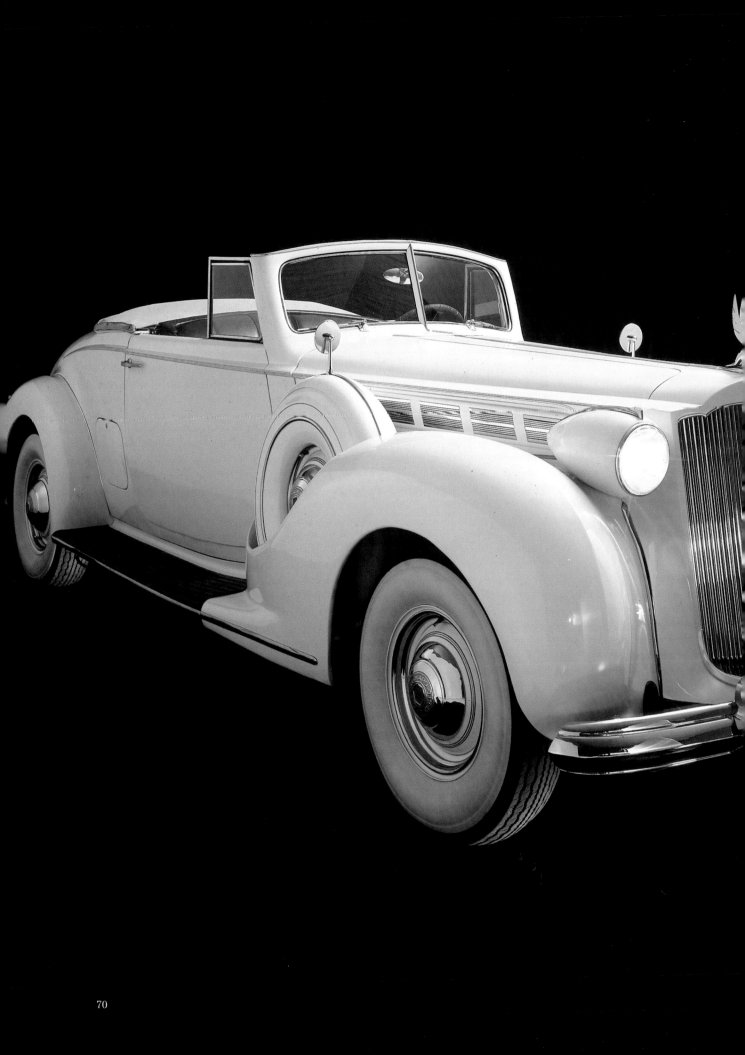

Shadows

Shadows add interest and excitement to an image. You can introduce atmosphere, create a mood, or suggest a sense of a time and place by making shadows important in a shot. Practical considerations play a role, too. For example, the highlights are often a given when you work with a light (especially a white) or bright object. You need to introduce shadows to create shape and give definition to your subject. Shadows can help move the eye through the photograph and create a sense of reality—of being in a "real" place—for the viewer.

SHADOWS: ADDING SHADOWS TO CREATE DEFINITION

We've done several posters for the Concours D'Elegance Classic Car Show (see the demonstration of the black Mercedes on pages 50-53 for another). This one was a beautiful white Packard, and we wanted to create an elegant, idealized vision of the car emphasizing its graceful lines and the detailing.

We started out with plenty of natural highlights—all we had to do was turn a lamp on the white car, and there they were. (Although the car looks green in some of the steps in this demonstration, it *was*

▶ The silk hung above the car worked like an enormous bank light, giving us a soft top light to bring out the edge of the windscreen. We used one large and one smaller board to create the band highlight on the grille. We added one more light facing the left front fender (the one you can see across the floor) to make the bumper brighter. We started trying to light the tires; you can see the strong highlight we got on the front hubcap.

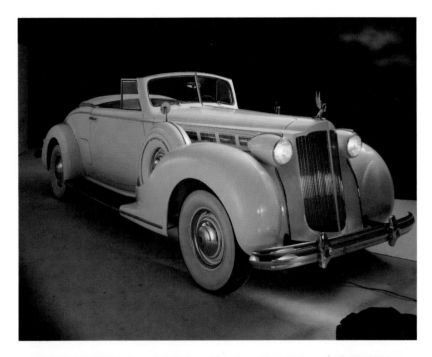

▶ To balance the lighting of the front and back tires we added a light under the car just to catch that back tire. We toned the accent on the front fender down to get rid of a highlight on the bumper. We took whatever we had lying around that was black and put it down to control the bounce.

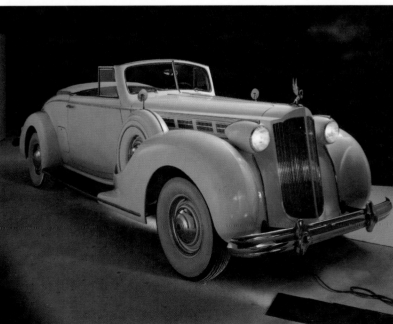

the same white car throughout the shoot. The color shift is due to the effect of the lights on the Polaroid film we used for tests.) This meant we could let all that white work for us and create shadows by letting the light fall off. We'd use the shadow areas to define dimensions, establish the shape of the car and the presence of the details.

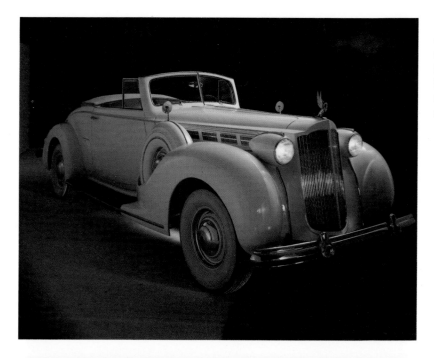

◄ We started putting black paper around to control the bounce and block off what the car was "seeing." We wanted to bounce the light to get the front and back tires more even. (Thinking back over the shot, I believe we spent more time lighting those tires than anything else.)

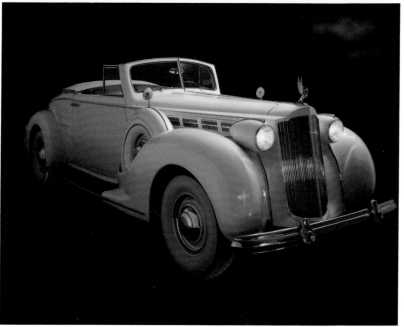

◄ Now we've surrounded the car with black cloth; note the change this made in the shadow on the door panel. The tires are also darker. When we looked at the previous Polaroid we realized we were losing the bumper, so we went back in and added another white board.

▶ The front tire looked good, but the back was dying after we put down the black cloth. So we had to balance the tires out again. We brightened up the light hitting the windshield, and Joe and I decided on our exposures. We'd go with seven pops of the strobe while leaving the headlamps on for sixteen seconds.

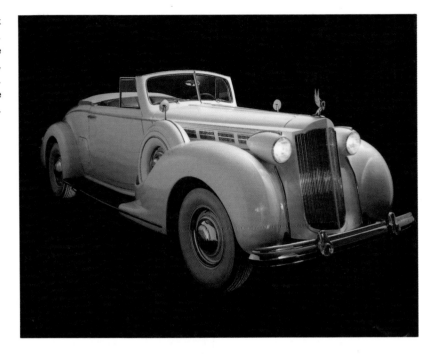

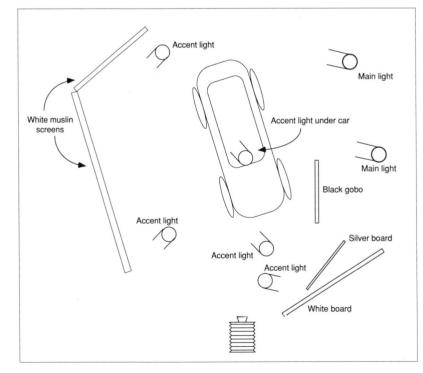

Accent light

Main light

White muslin screens

Accent light under car

Main light

Black gobo

Accent light

Silver board

Accent light

Accent light

White board

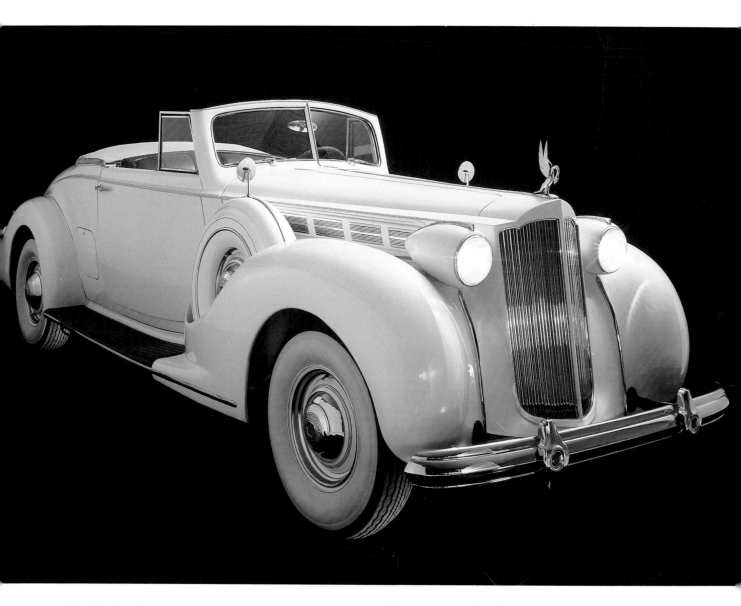

▲ We still had to make one more change in the lighting of the tires. We'd noticed in the last Polaroid that the highlight on the underside of the back tire really pulled the eye back there. We reduced the power in the light to keep the shape of the light but soften its intensity. If we'd feathered the light, we'd have destroyed the shape of the tire. We didn't want to put a screen in front of the light source either, because that would have changed the quality of the light. If you look closely you can see the silk we had suspended above the car for a fill light.

Client: The Arthritis Foundation
Photographers: Joe Braun & Alan Brown
Car Provided by: Jack O'Connor
Art Directors: Jim & Sue Slaughter
Design Studio: Slaughter & Slaughter
Studio Provided by: The Kraemer Group
Special Assistance: Jamie Ferguson

SHADOWS: ESTABLISH A SENSE OF TIME AND PLACE

The photo of Ben Franklin was part of a series for a company that specializes in planning parties and events. We chose a humorous concept for the series: four famous personages—Ben Franklin, Sitting Bull, Moses, and Santa Claus—who had just used, or should have used (as in Franklin's case), Premier Events for their special event or party. The sets and lighting played important roles in how well the visuals would succeed.

I wanted lighting that suggested it was late at night. I used a spot light with an orange gel over it outside the window to cast strong shadows suggesting a nighttime street light. I also set an Opalite (15-inch reflector) outside the window, placed very low, aimed at some seamless paper to add some tone to it.

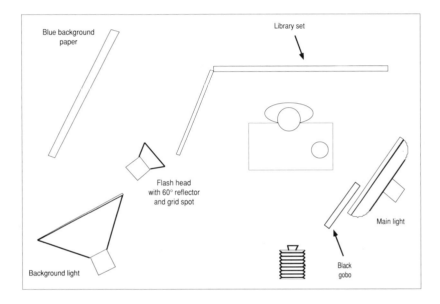

Blue background paper

Library set

Flash head with 60° reflector and grid spot

Main light

Background light

Black gobo

▶ I started with a single lightbox way off to the right to help suggest the lighting was coming from a single light source in the room, but that put too much shadow on the face.

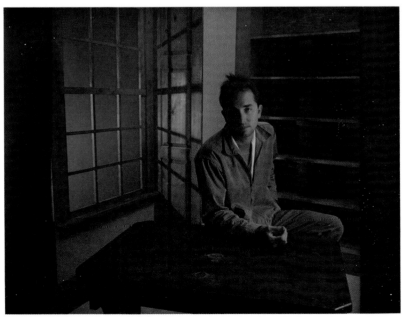

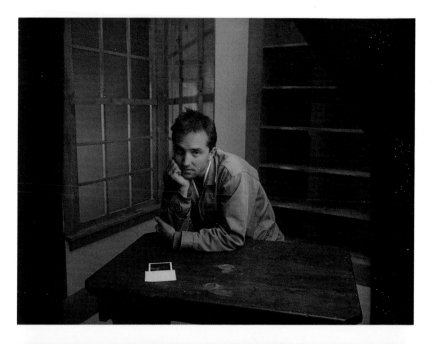

◀ So I brought the light around to the front, and came too far.

◀ I toned down the light to create more mood. So far I've left the light coming through the window alone; I'll work on it later.

◀ Although I wanted to suggest that the lighting might be coming from the desk oil lamp, I didn't want the light to be as low key as I'd get with just the oil lamp. So I put a light on the lamp. It was too bright, causing big splashy reflections and highlights, and I had to tone it down a bit.

▶ I added a gobo, then cut the outside lights (coming through the window) to check just the inside lighting. I placed a black board in front of the light and to the left to narrow down the highlight on the lamp.

▶ When I turned the outside lights on again, I toned down the light hitting the blue paper. I also added an orange gel to the small lamp for the shadows.

▶ I toned down the light on the blue paper even more and increased the light creating my shadows.

▲ I added an 85B warming filter to the lens to warm up the whole shot. Then I warmed the shot more when I was duping to make it still more orange.

Client: Premier Events
Photographer: Alan Brown
Model: J. S. Gorley
Stand-in: Brad Smith
Art Director: Lloyd Howell
Design Studio: The Plum Street Group

SHADOWS: REINFORCE THE AD'S CONCEPT WITH MOOD

Computer Technology Corporation wanted an image for a concept ad promoting a software program "so easy to use, it's like the computer is doing it all for you." (That's why you'll see a hand reaching out through the computer screen to touch the mouse.) I needed to give the shot an air of mystery to enhance the feeling that this program is magical, so I used shadows to create that mood.

Although designing the shadows was my primary concern when planning the shot, ultimately it was a highlight that really made it all work. I added a rim light to put a highlight down the right side of the sleeve and especially on the edge of the hand and the extended finger.

I also worked with two temperatures of light, an approach I've been experimenting with for some time. I felt this shot was perfect for the combination of the modeling lamp and the tungsten lights.

I needed to put together the images of the arm reaching through the computer monitor and the monitor with an active screen. So I decided the most effective way to do that would be to shoot the arm through a monitor shell first, then take the film out of the camera. I'd transfer the film holder to a second camera and shoot the second image, the screen.

Client: Computer Technologies Corp.
Photographer: Alan Brown
Art Director: Janine Hill
Agency: Jackson-Ridey & Co., Inc.

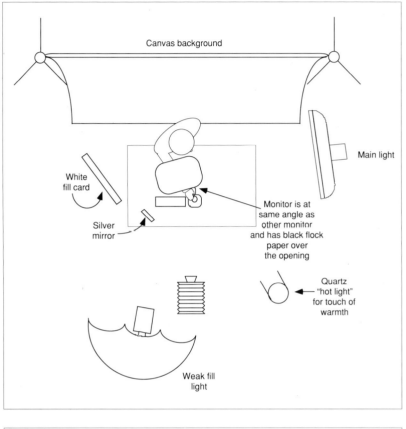

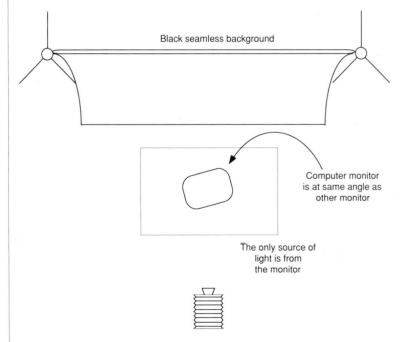

◀ Here's the initial setup of the monitor, keyboard, mouse, and software package. We adjusted the position of the arm and the various props to get an attractive, workable arrangement.

◀ Here's the second setup with the lighted image on the computer screen.

◀ And here's the test to see how shooting and moving the film to another camera would work. With the logistics settled, I was ready to work on the lighting.

▶ I decided to add the rim light at this point (look back at the previous page to see what a difference it made). I also moved the model's arm down from the test position. This changed the shadow and the contrast on the hand, playing well against the rim lighting. After looking at this Polaroid I decided I needed to add some diffusion.

▶ I made my own diffuser by spreading Vaseline on a piece of glass with a cotton swab and hanging it in front of the camera. I made my initial decision about where I wanted the diffusion by applying Vaseline while looking at the ground glass and took this Polaroid to see how it looked.

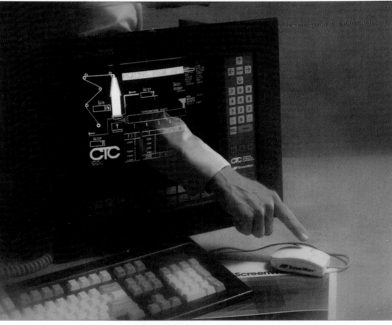

▶ I started moving the Vaseline around with the cotton swab, because I didn't think I carried the diffusion in properly over the keyboard the first time. I made the light softer and more even this time. I also worked on diffusing the edge of the screen. I added one more light to my original setup now. I added a tungsten light barn-doored down so it hit only the knuckles of the hand. This played up the knuckles and opened up the area at the bottom of the screen by the hand.

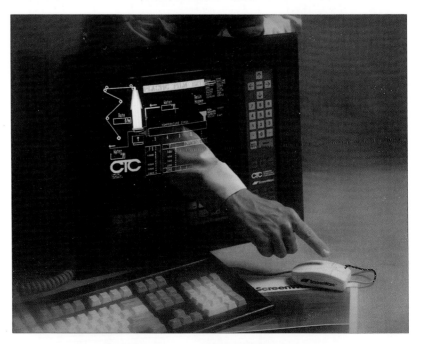

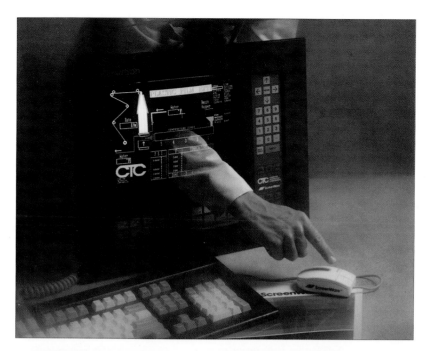

◀ I backed off the edge light down the top of the knuckles and the sleeve. I knew I'd have to reduce my exposure time rather than cut intensity because I was working with a model. Reducing the intensity would mean extending the amount of time he'd have to hold his arm perfectly still. I used two exposures for the first setup—one for the strobes and one for the modeling lamp, kicker light, and the tungsten lamp hitting the edge of the computer. I'd use a fifteen second exposure with the second camera after moving the film.

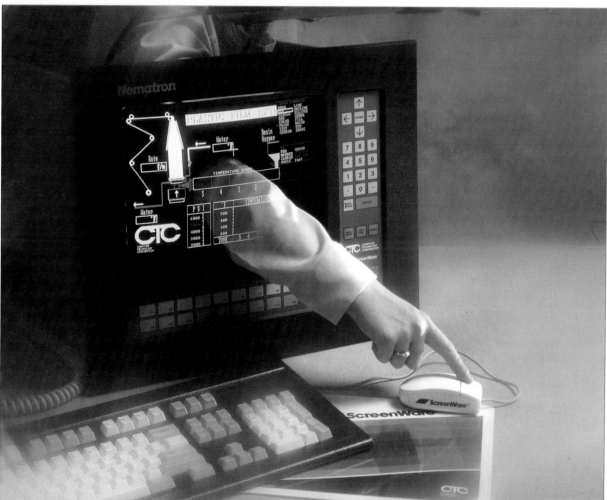

▲ I ended up toning the kicker down, but otherwise the shot was set. The client was quite pleased with this image even though I couldn't give them one element they wanted— the screen graphics flowing onto the model's sleeve. We did look at the possibilities of projecting a slide on the sleeve during the shot, but everybody felt that doing it at the pre-press stage on a computer retouching system would be the best way to go.

SHADOWS: GIVING THEM AN EERIE FEELING

This photograph was used for the cover of a magazine. Editorial photography or editorial illustration such as this has different needs and requirements than advertising photography. You aren't concerned with a precise rendition of your subject but with visually communicating a concept, transforming an intangible idea into a tangible image.

This assignment was creating a cover to illustrate the headline "Critic from Hell" for a story about *Cincinnati Magazine*'s food critic. The art director wanted a "sophisticated yet evil" look for the model to show the critic's elegant dining habits contrasted with her ability to pass judgment on—and perhaps do harm to the reputation of—a restaurant. Naturally the model,

Teri Jameson (hair, make-up, wardrobe, and expression) and the props (trident fork suggesting a devil's pitchfork and flaming food) and the special effects (the red fog) are important elements in carrying out the theme of sophisticated evil, but lighting also plays an essential part in supporting the concept.

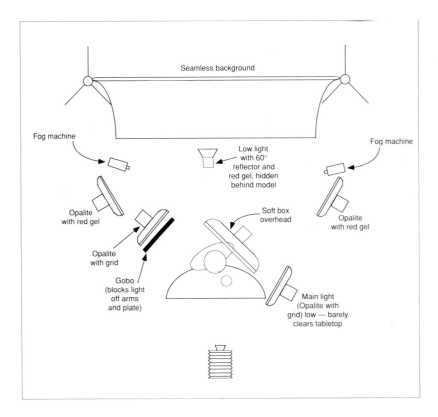

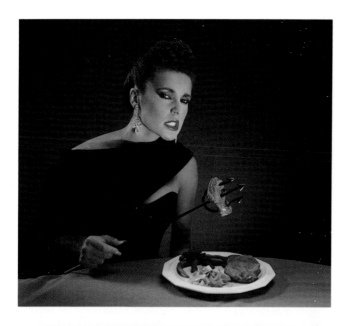

◀ The initial Polaroid revealed a number of problems. The main light was too broad and too high. Her whole face was evenly lit, while I wanted a more dramatic feeling with more shadows.

I placed an Opalite with a red gel behind the model on each side of the background to give an overall background illumination. A single light placed low behind the model put a brighter area in the center of the background. I had positioned a thirty-nine-inch softbox overhead to give definition to the top of the model's hair and to illuminate the food. But this didn't give me the results I wanted.

The model's hair was too dark, hiding much of the detail of the hairstyle and making her hair look very one-dimensional and flat. The hair light that was supposed to put highlight in her hair didn't do that very well and left a secondary shadow from the plate, her body, and her hand on the tablecloth. And the food was shadowed by her head and fork.

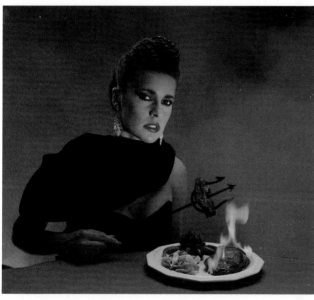

◀ I changed the lighting somewhat and did a full dress rehearsal complete with flaming food and belching smoke. I put a 30-degree grid spot on the main light (an $18^1/_2$-inch round Opalite) to restrict the light and lowered it as far as I could before the table began to block it. The light on her face was starting to take on the feel I was looking for, but it was too dark (her torso was in shadow) since the grid spot restricts the light passing through it in addition to directing it. I repositioned the top light to put more of a highlight in the top of her hair and to better illuminate the food. A gobo was placed in front of the hair light to block stray light from hitting her body or the plate, allowing the light to fall only on her neck and hair.

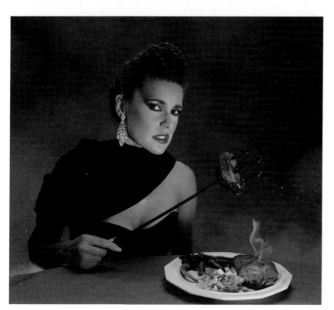

◀ At this point I changed the grid on the main light from a 30-degree to a 40-degree grid to increase its coverage. I then redirected it to light the model's shoulders and increased the power to brighten her overall. However, that light made the left side of her face too bright again. While the effect wasn't as bad as that in Polaroid #1, it lacked the eerie feeling of Polaroid #2. Also her chest was too bright, almost even in value with her face.

At this point I decided that we would do the remaining Polaroids without the fog machines running—to prevent asphyxiation of both the model and the crew!

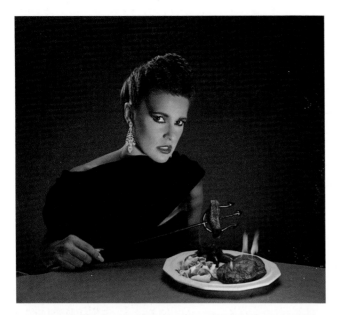

◀ I moved the main light eight to ten inches toward the background to solve the dilemma of not enough shadowing on the model's face. I could now direct it back full into her face while still keeping the left side mostly in shadow. Pointing it slightly upward made her face the brightest area, perhaps too bright. I also brought the hair light in closer and increased its power. It finally began to reveal the features of her hairstyle as well as giving the model a more three-dimensional appearance. I also lowered the top light to brighten the highlights in the top of her hair.

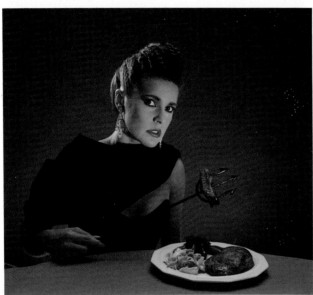

◀ Since I liked what changing the hair light did in the last Polaroid, I decided to Increase the power still more. Oops! Too much of a good thing can be harmful. Now the side of her hair is too bright and becomes a center of attention instead of a subtle, supporting element. I also decreased the main light power slightly to reduce the brightness on the model's face.

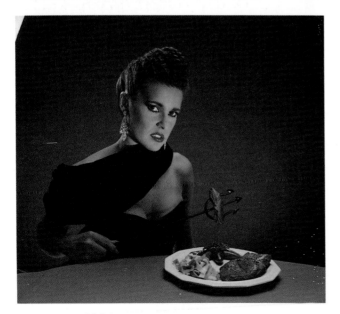

◀ Now for the last bit of fine tuning of the lighting. I returned the hair light to the power level I'd had with Polaroid #4 subtly illuminating and highlighting her hair. I tilted the main light down slightly to increase the light level on her chest while maintaining a brighter value on the face. I also slightly increased the power of the main light to emphasize her face a bit more. Now let's shoot film!

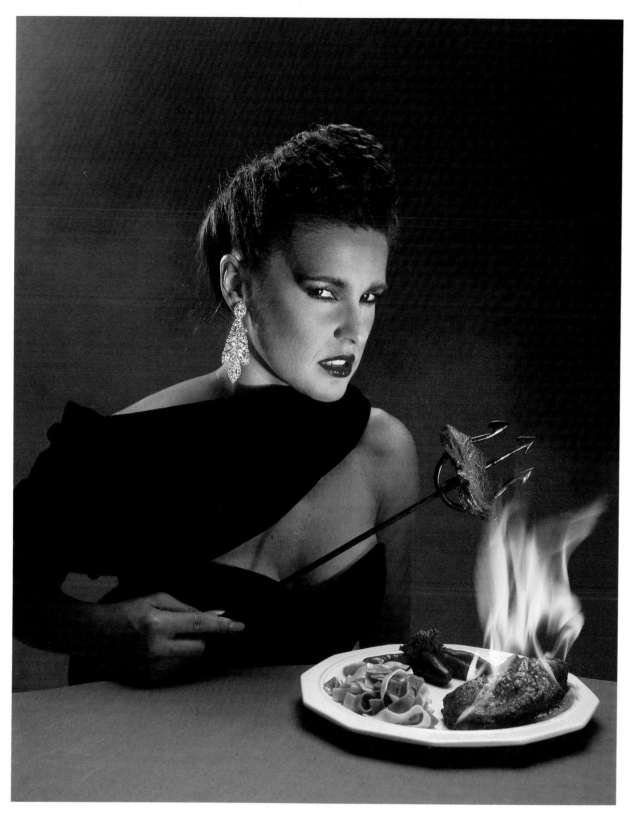

▲ The final image that appeared on the magazine cover incorporates all of the changes made throughout the lighting process with the red fog and flaming food.

The main light, placed low, looks somewhat unnatural and reinforces the evil and eerie feeling of her make-up. The hair light and top lights bring out the detail in her hair and illuminate the food sufficiently but don't make those areas compete with the brightness on her face for the center of interest. The intense flame actually casts a slightly warm glow on her face, enhancing the "devilish" look.

It took some work, but in the end the lighting worked well with the other elements of the photograph to create a mood that illustrated the story concept.

Client: *Cincinnati Magazine*
Photographer: Tim Grondin
Model: Teri Jameson
Art Director: Tom Hawley
Make-up & Hair: Aundra Lige
Food & Pyrotechnics: David Buchman

Highlights and Shadows

Although many of the shots we've discussed in the last two chapters involved both highlights and shadows, one or the other was more important. For the images in this chapter, we had to concern ourselves equally with both. Highlights and shadows combine to give objects shape, weight, and definition. They also work together to create a mood that falls between the zip of a primarily highlighted subject and the quieter mood that shadows create. You'll also see how highlights and shadows play an important role when we're working with special techniques or in unusual situations.

HIGHLIGHTS & SHADOWS: ONE BASIC LIGHTING FOR TWO EFFECTS

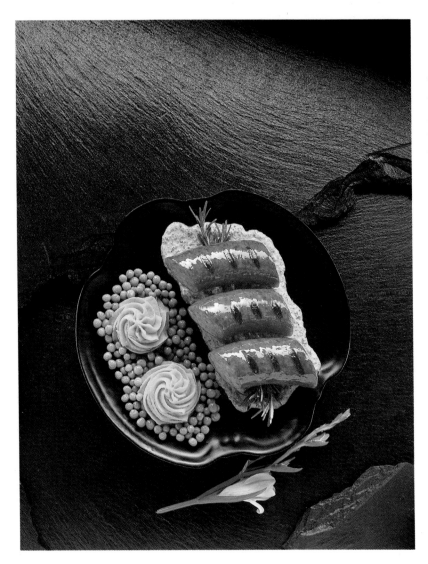

When shooting food it's important to show the food's texture and give it rich, saturated colors. Showing texture helps the viewer imagine what it will taste like when they eat it. Rich color makes the viewer feel that the food will be fresh and flavorful. When I shoot food my goal is to make viewers feel they want to take a bite right out of the picture. That won't happen if the food looks flat, pale, and mushy. Lighting plays a very important role in making food look good.

Client: Hillshire Farms
Photographer: Joe Braun
Art Director: Ray Mueller
Agency: Northlich Stolley LaWarre
Food Stylist: Lisa DeVille

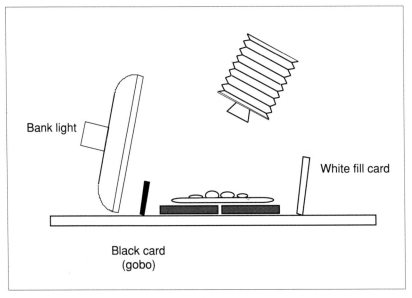

Bank light

White fill card

Black card
(gobo)

▶ Although the final effect of each image is quite different, I used the same basic approach to lighting both the Hillshire Farms sausage and the chateaubriand. As you can see in the lighting diagrams, the main light is set at a low angle to the subject and slightly to the rear of the set. This allows the light to skim across the food, producing highlights and shadows that define and enhance the texture of the foods. At the same time I was careful not to use too broad a light source for the main light because that would make the highlight areas spread out very wide, causing a decrease in color saturation and overall contrast. I also used a white fill card placed directly opposite the main light in both cases to fill in some of the shadow areas.

While the basic lighting scheme of these two photographs was the same, I had to handle each shot somewhat differently to produce final effects appropriate to each type of food. The choice of props and the colors of the background setting also dictated some differences in approach. Let's look at the Hillshire Farms sausage shot first.

Client: PhotoDesign self-promotion
Photographer: Joe Braun
Food Stylist: Lisa DeVille

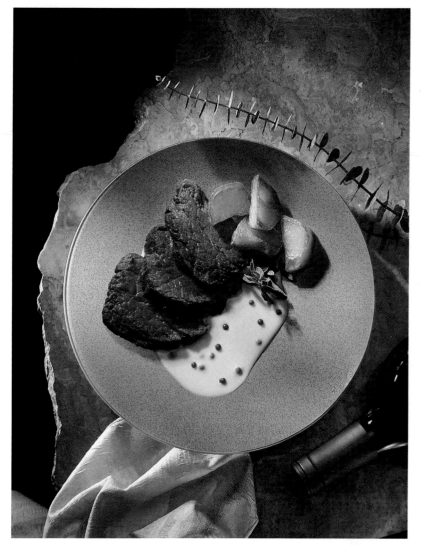

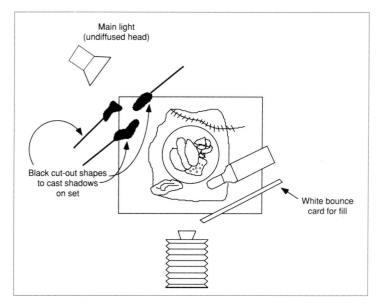

Main light
(undiffused head)

Black cut-out shapes
to cast shadows
on set

White bounce
card for fill

◀ I chose a diffused main light source for three reasons. First, I didn't want any sharp, heavy shadows that would be difficult to fill in because of the shapes of the food and the set. Second, the diffused light source would give me a nicely shaped, well-defined highlight in the sausage to give it some dimension.

◀ Finally, a diffused main light source would bring out the texture of the slate background beautifully, but keep the overall contrast of the background low to keep the emphasis on the food.

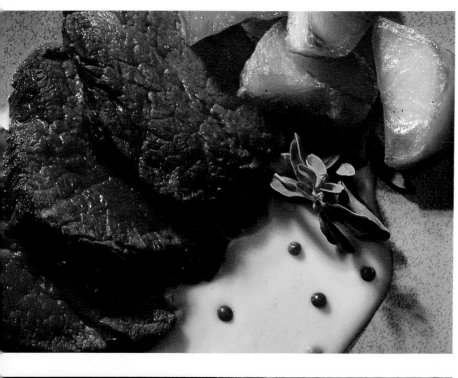

◄ I wanted a more dramatic lighting for the chateaubriand so I used a direct, undiffused main light source to produce sharp, clearly defined shadows. I used a small light source to keep the highlight areas in the food small to maximize the color saturation in the food.

◄ I also projected additional shadows on the plate and the marble background by strategically placing shapes cut from black paper between the light source and subject to further enhance the romantic, elegant mood I wanted to create.

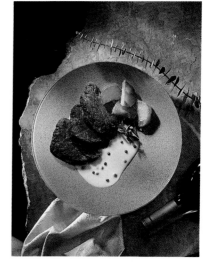

HIGHLIGHTS & SHADOWS: SHAPE AND DEFINE SMALL OBJECTS

Highlights and shadows give objects shape, weight, and definition. It can be particularly challenging to light small objects so they have a good balance of highlights and shadows. And it's even trickier when the small objects are being photographed almost life-size.

This shot of a pin, a group of marbles, a needle, a thimble, a stamp, and a yo-yo was a self-assignment to demonstrate how I could make small objects or products look interesting through lighting and composition.

I knew that I wanted a rather directional (hard) light source so I would get some definite shadows under the objects. At the same time I didn't want the light to be so directional (hard) that it would make the shadows hard-edged and very long. I also wanted to avoid using too large a light source because that would not give me enough control over the size, shape, and direction of the shadows or the highlights. So I used a single flash head with a 65-degree reflector and aimed the light through a small diffusion screen. I placed the flash head very close to the screen, approximately six inches away. This kept the light directional but still somewhat diffused, allowing for smaller highlight areas in the marbles and giving nice defined shadows under all the objects.

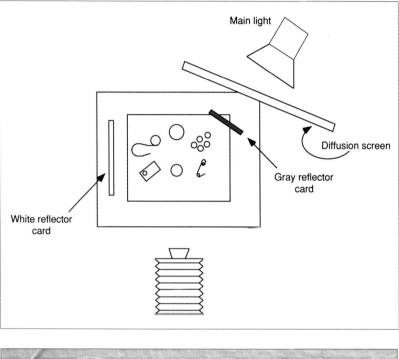

▲ I started out with just the marbles, the pin, and the needle shot from a fairly high camera angle. As you can tell from the small reflection in the lower left portion of each of the red marbles, I had placed a small white card to the left in order to put a reflection in the sewing needle and to lighten the paper background on the left side of the set.

◄ I added the postage stamp and moved the reflector from the left of the set to directly over the top of the set in order to reflect light into the safety pin. This would give the pin a brighter metal "look."

▼ Although putting the reflector over the set improved the look of the safety pin, I'd lost my reflection in the needle. To correct this I added another reflector to the left of the set. This also opened up the shadow areas a little.

At this point I felt satisfied with the lighting, but the shot itself just wasn't interesting enough for me. I also didn't like the very obvious rectangular reflections in the red marbles. I knew I needed to change the shot but didn't know exactly how. I began to walk around the set, first to the left, then to the right. As I moved left to right, I was also raising and lowering my head while watching the marbles and pins and noticing how the highlights and reflections changed as I moved.

I moved a foot to the left and looked from a low angle (four inches off the background) and noticed that the main light coming through the screen reflected really nicely into the safety pin. Changing to this low angle would allow me to get the look I wanted for the pin without having to put a reflector card above the set. Getting rid of that reflector card would eliminate the odd-looking rectangular reflections in the red marbles.

In addition to changing the camera angle I decided to add a couple of more elements to the shot. I felt this would help the composition and maybe give the shot an intimate, "on top of your dresser" kind of feeling.

► As you can see here I added the thimble and the yo-yo. I liked the color of the yo-yo and the way light passed through it, projecting its color on the background the same way the marbles already did. The thimble just seemed to make sense with the needle and thread and had an interesting texture on the tip. Also notice the different look and feel from the lower camera angle. It's more intimate, making you feel you're a part of the photo, moving through it. The lower camera angle also puts more emphasis on the shadows under the objects and on the projected light passing through the marbles and the yo-yo.

► I made a slight change here by lowering the main light a few inches. This made the shadows a little longer and a bit heavier (darker) and narrowed the highlight areas slightly. I also added a gray card back behind the set to darken the top right corner of the photograph. When I looked at the previous Polaroid I'd felt this area was so bright that it was distracting.

▲ I moved the gray card in much closer to the objects, projecting a shadow in the top right corner. This shadow added the final touch to the composition. It keeps the viewer's eye and attention focused more in the center of the photo and allows the eye to move in a circular fashion while looking at the photograph. When the eye moves this way the viewer can appreciate all the elements in the photo, making it more successful.

Client: PhotoDesign self-promotion
Photographer: Joe Braun

HIGHLIGHTS & SHADOWS: CREATE CONTRASTS AND DETAILING

Every year the Cincinnati Symphony Orchestra uses a visual on their promotional material that has to say "orchestra music" in a distinctive, original way. For this shot the designer and I wanted to do a painterly image of a musical instrument with a very surreal, stylized feel to it. We wanted to do something with a wrapped instrument because this image would be used in conjunction with one of a wrapped trumpet we were doing for the Cincinnati Pops Orchestra (see pages 24-25).

The wall, built out of drywall and plaster, was painted with oil paints in an impasto technique (a thick application of paint with the brushstrokes showing for a highly textured effect). I wanted the brushstrokes on the shutter showing to contrast and to complement the fabric wrapped around the cello.

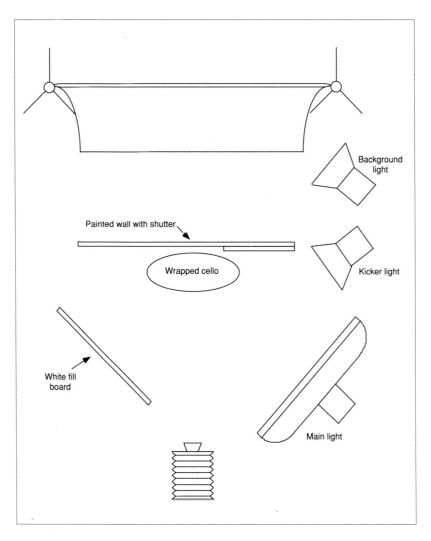

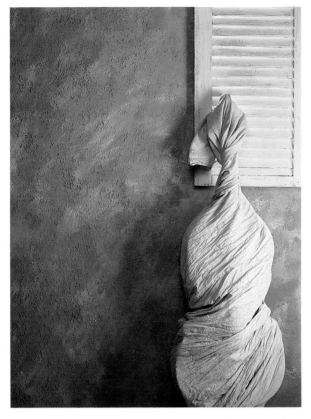

▲ I started out experimenting with shadows cast by the cello, but I couldn't get shadows I really wanted. The shot called for very surreal, stylized shadows that proved physically impossible to create.

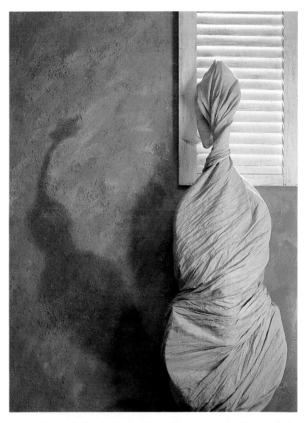

▲ So I cheated. The shadow outline of the wrapped cello is real, the shadow farther left is painted on the wall. I also increased the intensity of the shutter light and added a fill board on the left hand side.

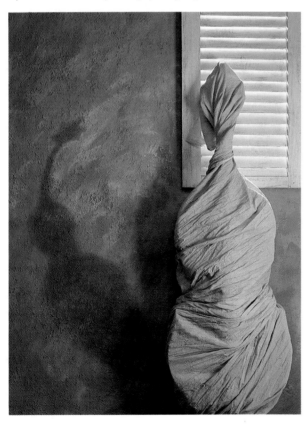

▲ It felt like the fabric needed to be more on the green side. Rather than unwrap and rewrap the whole cello, we sprayed the fabric to make it more teal. As it turned out, I didn't like that effect and decided to stay with the original color design.

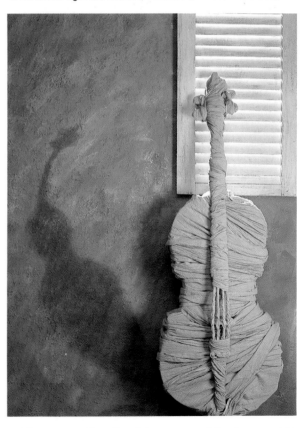

▲ We rewrapped the cello to bring out more of the character of the instrument. The client didn't like it. They didn't like the color design and felt the wrap was too tight, giving too much definition to the instrument.

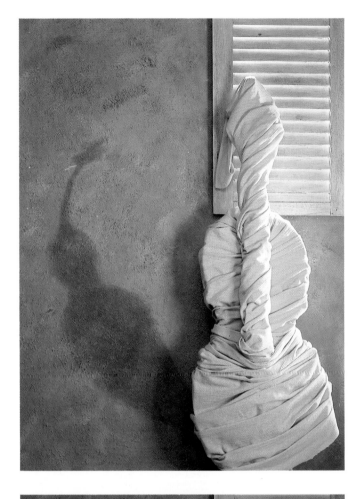

◀ So we repainted the wall and made the color of the shutter darker in value and more pink. We dyed the fabric a brighter, warmer, greener shade of blue and tried a looser wrap. I didn't feel this was as successful, because it called too much attention to the fabric—and changed it again. The changes in the colors of the prop and the set made it necessary to add a kicker light to get the highlights on the right-hand side of the neck and the cello itself.

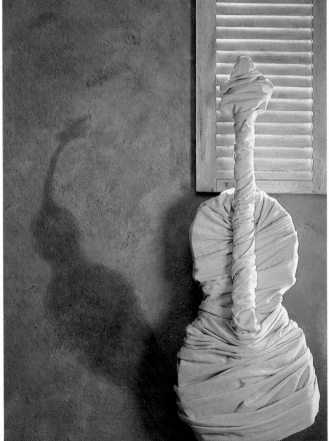

◀ I tightened up the fabric again and changed the exposure.

▶ We wrapped the whole thing one more time (we went through a total of seven different wraps during the shoot!) to bring out the strings. The tighter wrap gave me a more interesting composition; it brought out the highlights on the right side better, and the shadow it created helped to define the detailing on the instrument. There's now a great contrast between the shadow on the one side and the highlight on the other.

Client: Cincinnati Symphony Orchestra
Photographer: Alan Brown
Art Director: Liz Kathman Grubow
Design Studio: Libby, Perszyk, Kathman
Set Painter: Guntis Apse

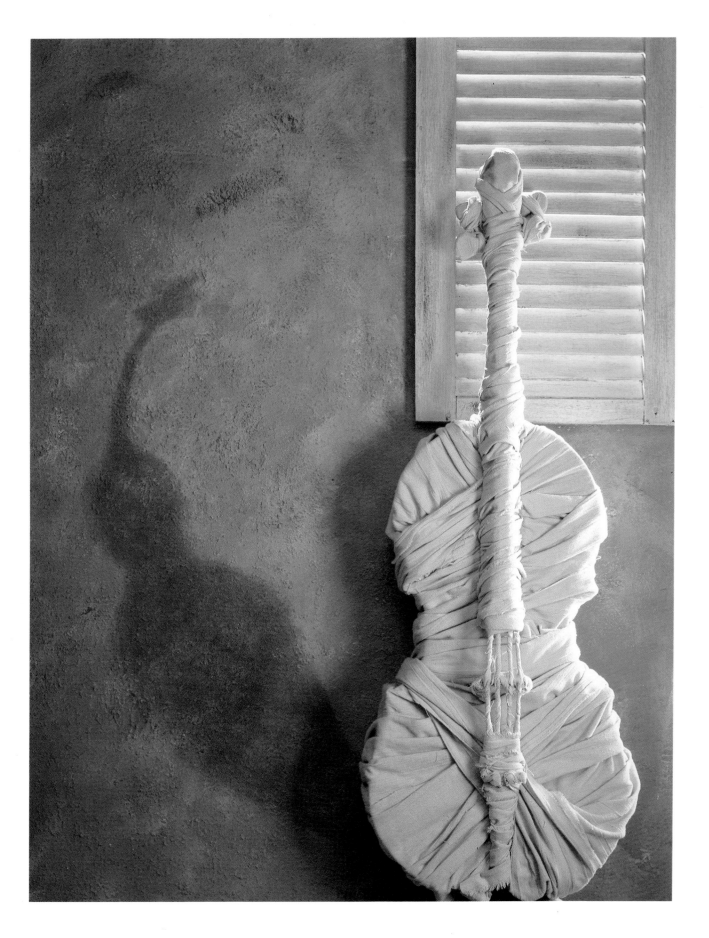

This was part of a series of photographs we produced for a calendar for the Cincinnati Symphony Orchestra. My approach to lighting it was based on the way certain elements or objects reflect. How something reflects can create highlights, middle tones, or shadows in a photograph. It can also convey a sense of mood; for example, bright sunlight dappling the surface of a breezy lake might give you a sense of hope or joy. Late evening blue sky reflecting into a motionless, watery surface with floating leaves could evoke quiet introspection or even sorrow. The mood I wanted to convey was one of a quiet, early morning walk around a pond...then a discovery!

I wanted a smooth, continuous reflection around the objects in the water but at the same time some variation in tone in this reflection. I had to choose what I was going to reflect into the water to get across the early morning, slightly hazy effect of morning sun and sky reflecting into a pool. I also wanted the "sunny" part of the reflection (that brighter area in the upper right portion) contained to the area where the frog was in order to focus a little more attention in that area. Conversely, I wanted the lower left portion of the photo to fall into shadow so as not to focus too much attention in that area. I wanted the transition between these two areas to be smooth; an abrupt change would detract from the primary elements, the frog and clarinet.

Client: Cincinnati Symphony Orchestra
Photographer: Joe Braun
Art Director: Liz Kathman Grubow
Design Studio: Libby, Perszky, Kathman

102

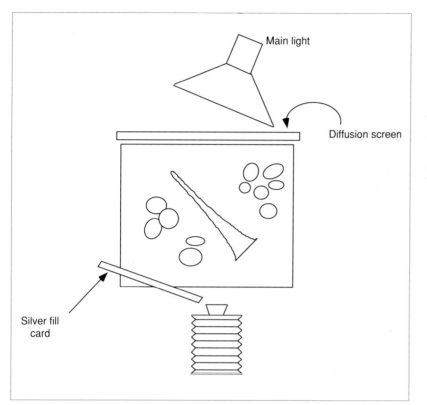

Main light

Diffusion screen

Silver fill card

◀ This same reflection would also be seen by the chrome keys and trim on the clarinet where I wanted a nice, even, satin chrome look. The solution to this lighting problem was placing a screen behind the set and moving it toward the camera until the reflection was continuous across the surface of the water. Then by placing a light behind the screen and off to the right, I was able to achieve a brighter reflection in the upper right portion of the photograph that fell off progressively darker from right to left.

◀ In order to keep the mood quiet, I wanted to make sure not to reflect too much light into the water. I put black plastic under the water which helped tremendously and gave an interesting secondary middle gray reflection around all the objects that were placed in the water.

103

▶ One problem remained. I wasn't happy with the flat look of the brighter reflection on the water. As I thought about it and nervously tapped my fingers on the surface of the water, the answer appeared right in front of me. Gently tapping the water in the upper right portion of the photograph as I exposed the film produced rippling waves in that area giving it some dimension, interest, and a touch of mystery.

◄ Because the light was coming from a low angle through the screen, it produced crisp, well-defined highlights where the edges of some of the rocks met the water. These highlights helped define the shape of the rocks, added visual interest, and created a visual balance with the highlights in the chrome keys.

▼ The entire screen was reflected in the rounded chrome keys and trim of the clarinet, giving them a nice satin look. The only problem remaining was that the near edge of the clarinet next to the water was going very dark as were some of the chrome trim pieces on the same side. I added a silver reflector card to the left side of the set close to the clarinet and placed it low to bring some detail out of the black wood and chrome pieces on the bottom near edge of the clarinet. This also added small highlights around the edges of the black rocks, giving them a little more dimension.

I created this image to show off some new technology: the capabilities of electronic still video photography and computer manipulation of images. (I also had an incredible urge to finally use two masks that I had purchased at a Soho gallery in New York several years ago.) The electronic still video camera recorded the information in the scene with its own bias toward a coarser image. I manipulated the image in the computer to enhance some of the colors in the photo while playing down others. I used a film recorder hooked up to the computer to transfer the final image onto 35mm slide film.

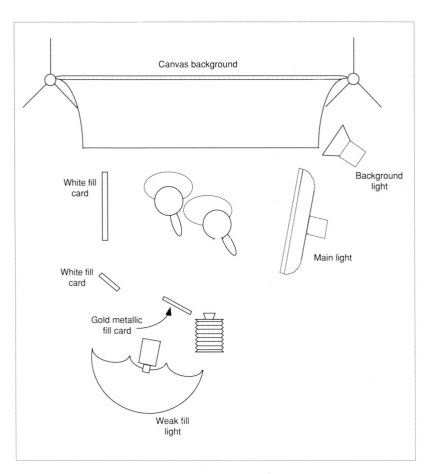

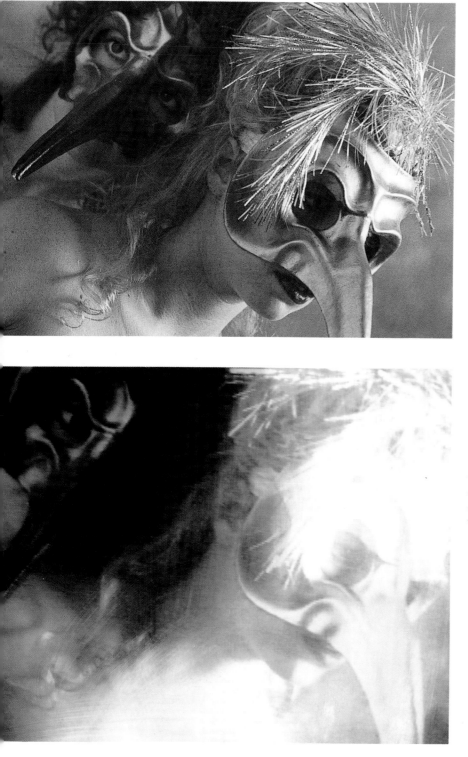

◀ My key light was a lightbox off to the right. It was positioned high and fairly far from the models to make the effect of the light a little crisper than if it were used very close. A gold fill board was used on the left to help open up the shadow areas as well as to add some more interesting highlights in the masks, which have a dull, gold metallic quality to their colors.

◀ A still video camera gives a greater polarization of the blacks and whites, while losing most of the midtones. I have to light with a higher contrast when using conventional film to get the same drop-off of midtones. Regular film captures a lot of subtle nuances that still video flattens out or loses. Knowing this would happen, I used a softer lighting and explored the textures of the drop-off. (For another example of lighting and working with the still video camera see pages 122-125.)

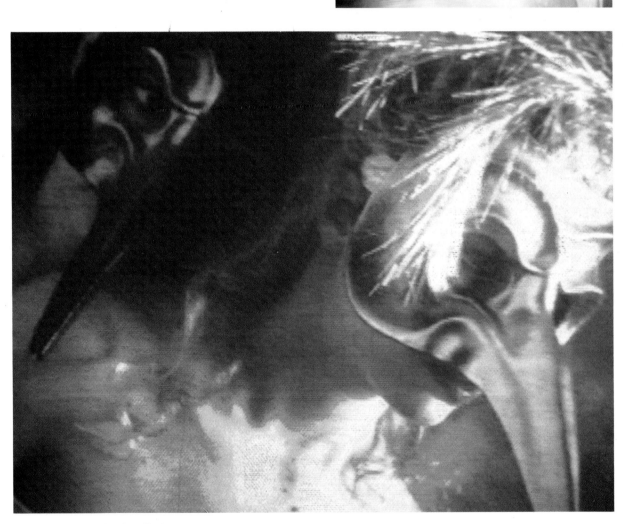

▲ I started to manipulate the still video image to make a particular statement. I wanted the image to look like an engraving with the texture of an etching on metal. This first manipulation doesn't work for me because it's too moody. The colors are too basic, the edges are too soft, and it lacks the texture of an engraving.

▲ The second manipulation works better because it has a coarse texture. I achieved this texture by applying a sharpening algorithm to the image to break it up. This deleted the dither effect (gray tones) until there were hard edges. Gray areas are made up of black and white areas now. Then I went in and applied color tints (simulated light watercolor washes) to the fleshtones, neck, lips, gold mask, and the background. No tints were added to the black mask, the feathers, or the blond hair.

Client: PhotoDesign self-promotion
Photographer: Alan Brown
Models: Athena Eliopulos
& Regina Mikonis
Special Equipment: Canon Electronic Still
Video Camera & Macintosh Computer

Lighting for Effect

Lighting for effect includes using light and shadow as graphic design elements, suggesting a mood or a place, exaggerating certain characteristics of a subject, or creating special effects. In many of the images in this chapter we're manipulating the viewer's perceptions—making a lily glow or simulating a charcoal fire. The final image in this chapter looks specifically at a subtractive approach to lighting.

This was the photograph for our second Cincinnati Chamber Orchestra poster. For this image, the art director and I wanted to achieve a sense of the musical sound coming out of the cello. We decided that a glowing lily strumming vibrating strings would help to create this illusion.

I placed a small spotlight behind the cello to create some depth and separation from the background. I experimented with placing a purple gel over this light, but finally decided not to use it.

I started off by lighting the cello from the left with a long softbox to create a highlight that ran the length of the body of the cello.

I used a small silver reflector in closer near the neck to create a subtle rim light edge.

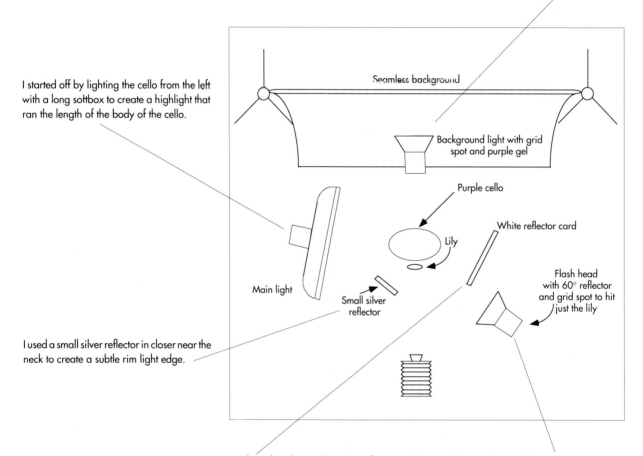

On the right side, I used a white reflector card backed away from the cello to add just a weak amount of fill light bouncing into the right side.

Finally, I used a spotlight scrimmed down to a narrow beam that just hit the lily. In combination with a pastel filter over the lens, this light created a glow around the lily.

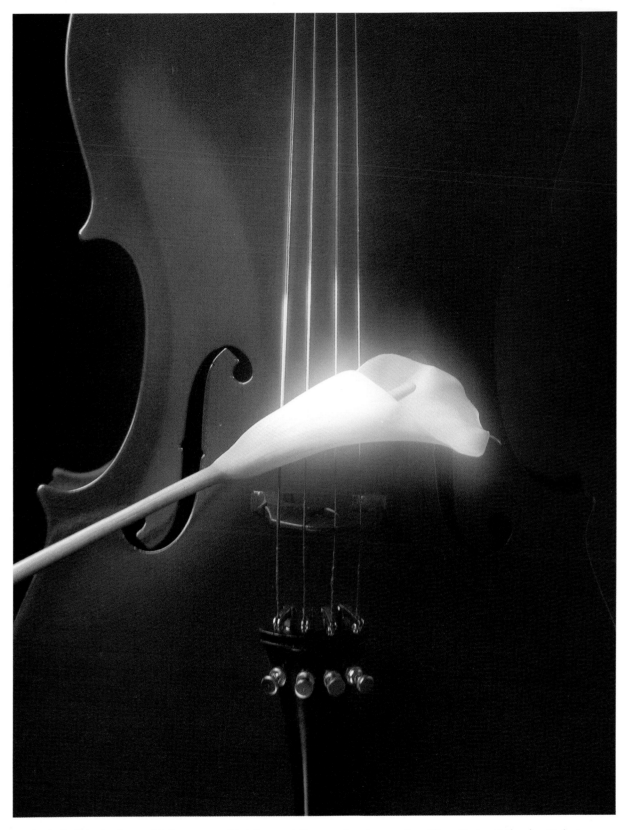

▲ I backed off the background light even further to eliminate all the fill on the right side. I put the gel back on then, too, and decided to switch from Fuji 50 to Ektachrome 64. This change gave me the purples I wanted. I added the pastel filter to soften the overall image, and you can see the effect of my shaking the camera while the art director plucked the strings and my assistant shook the lily.

Client: Cincinnati Chamber Orchestra
Photographer: Alan Brown
Cello Provided by: The Baroque Violin Shop
Art Director: Tony Magliano
Agency: The Martiny Co.

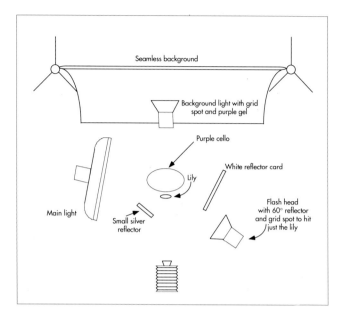

◄ The image consists of three separate exposures all made on the same piece of film. With each exposure we employed a specific effect so the cumulative total would give the image the atmosphere we were looking for. The first exposure was my overall lighting of the instrument.

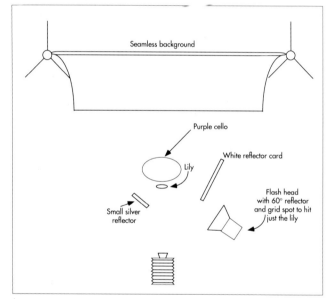
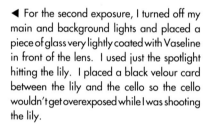

◄ For the second exposure, I turned off my main and background lights and placed a piece of glass very lightly coated with Vaseline in front of the lens. I used just the spotlight hitting the lily. I placed a black velour card between the lily and the cello so the cello wouldn't get overexposed while I was shooting the lily.

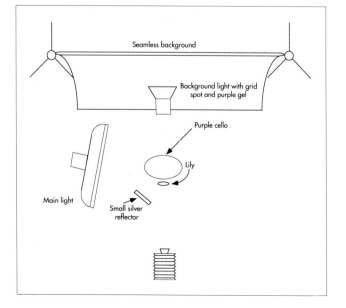

◄ The third exposure involved turning off the lily spotlight. For this exposure, I placed a blue color-correction filter over the lens to compensate for my modeling light being color-balanced for tungsten light while my film was balanced for daylight color. I also used a pastel filter over the lens to soften the image. For the final image I banged on the side of the camera, while the art director plucked the strings of the cello (outside the image area), and the assistant tapped the lily.

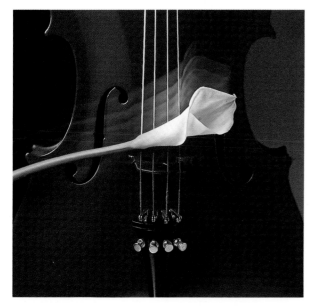

▲ I started out working with Fuji 50 film, because I wanted real good purples. Here we tried multiple exposures, moving the lily and manipulating the back of the camera between each pop.

▲ I decided that having the strings yellow all the way led the eye out of the image. So we sprayed the upper part of the strings the same color as the cello. I toned down the background light to kill the purple glow. This time I tried leaving the shutter open for a 30-second exposure while we tapped the stem of the lily.

▲ I felt the strings were still too dominant, so we sprayed color over more of the strings. I took the gel off the background light to kill the purple glow completely. I decided to change the look of the lily, too, sliding the stamen out so it was now visible. The effect of tapping the lily was closer to what I wanted but still not right, so I tried tapping the camera as well as the lily.

▲ I now decided I needed less fill on the right side, so I toned down the background light. The only other change I made from the previous shot was to switch film—this is Fuji 100.

LIGHTING FOR EFFECT: EXAGGERATING THE EFFECT OF COLOR

Strawberry Jello shows how lighting can be used to exaggerate certain characteristics of a subject, in this case the way light can enhance color. The idea started with a movie I saw in which an actor pulled food from a refrigerator in one scene. In a close-up a hand pulled out a piece of red Jello on a spoon. Lit only by the light coming from the refrigerator behind it, the Jello seemed to glow a brilliant red. I started thinking how I could re-create that effect to make an eye-popping image for our portfolio by playing that intense, saturated red for all it was worth.

I consulted Lisa DeVille, a very talented food stylist, and we decided that strawberry-flavored Jello would give me the kind of red I wanted. After looking at different molds, we chose a bell-shaped mold because it had a nice shape and good detailing around the top. We also decided to add fresh strawberries to the Jello in order to add some interesting shapes and textures inside the Jello itself. Lisa determined that we'd need five times the normal amount of gelatin mix so the mold could withstand the heat of the modeling lights on the set. Then I started to experiment with the lighting.

◄ I started by lighting the Jello only from behind. As you can see here, this produced the really intense red I wanted, but I didn't like the fact that there was nothing to give a sense of the shape of the outside of the Jello. It just looked like a bright red blob.

◄ I moved some of my black paper behind the set so the light, coming from behind and slightly to the right (out of the image area), spilled onto the right side of the Jello. I noticed a bright highlight that gave nice definition to the outer surface. I liked the effect, but I wanted to get a broader highlight that would define some of the facets that were part of the shape of the Jello. (I also decided it would work better on the left side.)

117

▶ I took a small piece of translucent Plexiglas (about 12" x 18") and put it to the left of the set in front of most of the light that was spilling onto the left side of the Jello. I left a thin (one-inch wide) band of the direct light coming from the rear, which held the well-defined edge of the molded Jello.

▶ I placed the Plexiglas at an angle coming from slightly behind the Jello to the front of the set. (See the lighting diagram on page 120 for how this works.) This produced a very nice, soft, wide highlight in a couple of the facets on the left side of the Jello, defining them nicely.

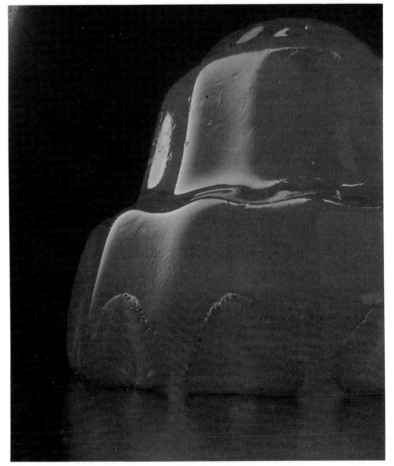

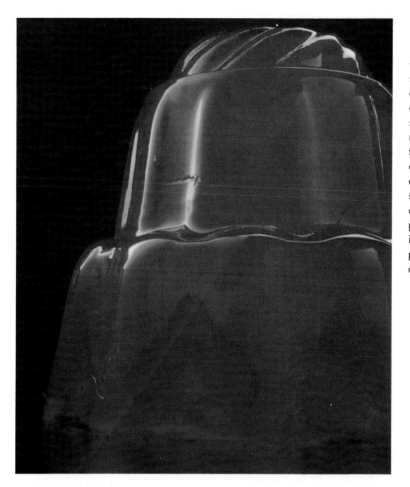

◀ I also added a white fill board in front and slightly to the right of the Jello, which produced another, slightly softer, wide highlight on the outer surface of the right side of the Jello. I let some of the direct light from behind and to the right spill onto the right side and part of the top crown of the Jello. (We also switched to a slightly different mold to enhance the lighting effect.) Now I had my well-defined edges and soft highlights that defined the shape of the outer surface of the Jello. At this point, I was pretty satisfied with the lighting of the Jello itself but not with the aesthetics of the overall photograph. It needed something else, but I didn't know what.

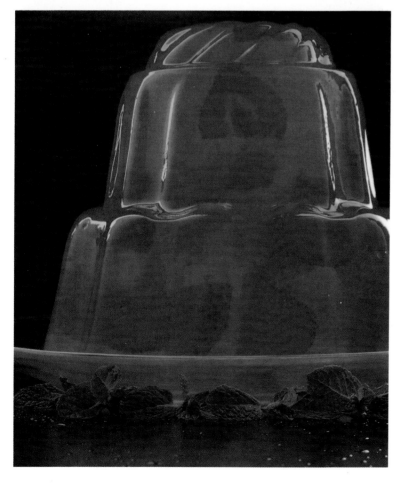

◀ I talked it over with Lisa, the food stylist, and we decided to put the Jello on a glass plate and add several sprigs of mint underneath the plate. Adding the mint sprigs would not only add a decorative touch and a nice splash of fresh, contrasting color, but also mask some of the reflections underneath the lip of the plate. However, as you can see here, the mint looked dark, not green.

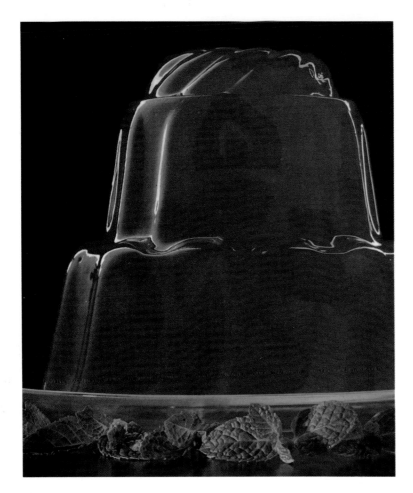

◀ In order to get the fresh mint color to come through, I placed an additional flash head with a 35-degree grid spot attachment to the left of the set at plate level and aimed it directly at the mint sprigs. I narrowed down the beam of light from this head even more by taking a small (3" x 5") black card and cutting a notch along the bottom edge of it. When I put this over the light, it kept any of the light from spilling up onto the Jello. This brightened the mint and brought out its green color.

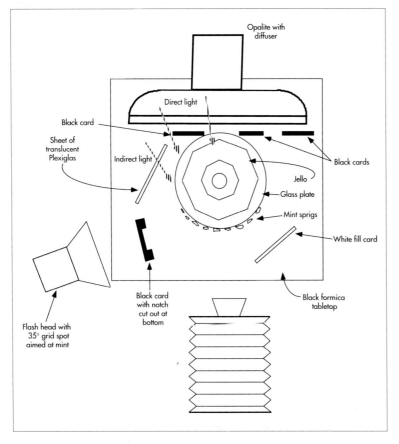

Opalite with diffuser

Direct light

Black card

Sheet of translucent Plexiglas

Indirect light

Black cards

Jello

Glass plate

Mint sprigs

White fill card

Black card with notch cut out at bottom

Black formica tabletop

Flash head with 35° grid spot aimed at mint

Client: PhotoDesign self-promotion
Food Stylist: Lisa DeVille

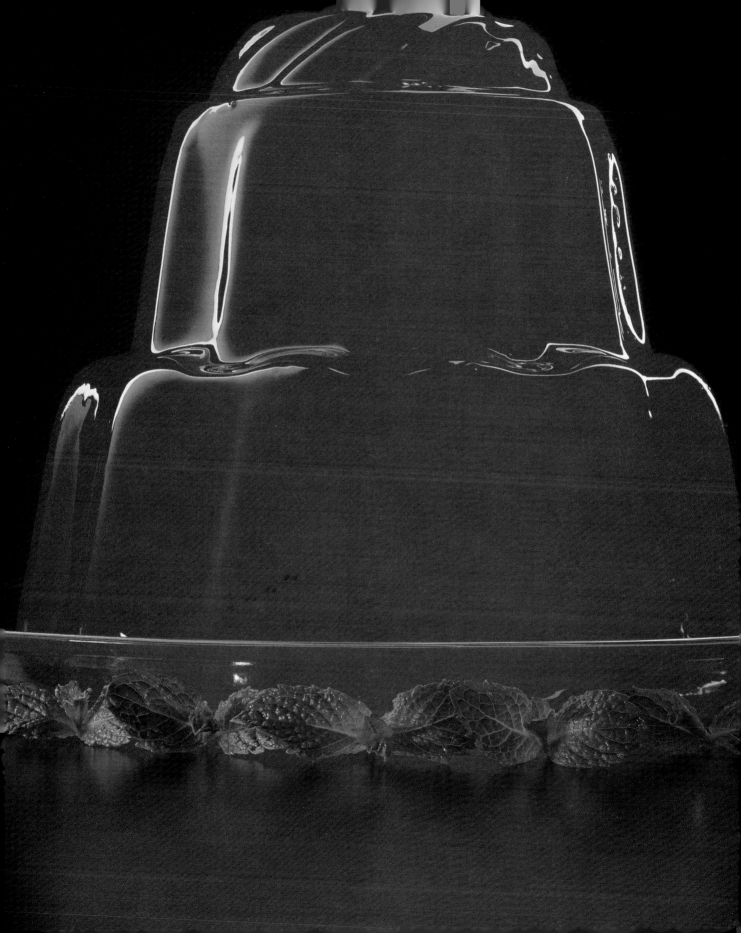

LIGHTING FOR EFFECT: LIGHT + TECHNOLOGY = NEW STYLE

This photograph was one of four to be used in a subscription brochure that the Cincinnati Opera planned to send to current and prospective subscribers for their next season of romantic operas. The art director, marketing director, and I felt that the images should all have a warm, soft, illustrative feel to them. This approach would convey a romantic feeling to the viewer—capturing the motif for the season. I proposed using a new technique I'd been experimenting with, electronic still video technology, as the best way of getting the right look.

In electronic still video technology a video floppy disk stores the image information in the form of an analog signal. This signal is brought into a computer with a framegrabber board, and a film recorder is used to produce a final 35mm transparency. Electronic still videos are not yet widely used for studio work because the resolution is much lower than what you can get with conventional photography. However, this lower resolution plays an important role in getting the soft, illustrative look for this series of images.

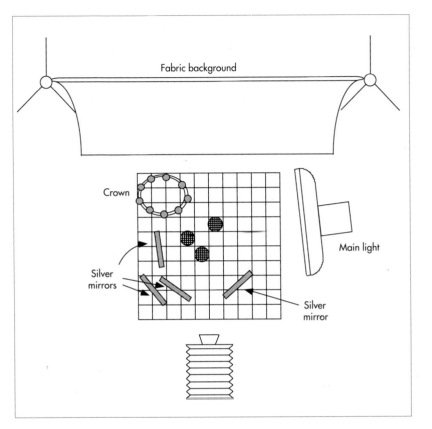

▲ The still video camera has a white balance control that enables the photographer to adjust its color balance to the types of lights being used. I set the camera to correct for tungsten lights and used the modeling lamps as my light source. Although I'd normally use flashtubes, I went with the modeling lamps because I could more easily adjust the lamp intensities in minute amounts than by turning up and down the power to the power packs. I could see the changes with the lamps; with the power packs, I'd have had to shoot a frame and then review it. (With electronic still video, you can shoot an image and immediately play it back on a monitor. You can see what you're going to get without waiting for a film test to come back from the lab.)

◀ The main light was feathered toward the camera so that just a little soft light fell on the background. (The light was aimed so that the main part of light didn't fall on the place I was lighting.) This gave depth to the background without calling a lot of attention to it because the quality of light was softer toward the edges of the reflector and less concentrated.

◀ I used a small Opalite off to the right because I didn't want the chess pieces to be too bright, but then they weren't lit up evenly. I added fill boards on the left side and in front of the set so I could pick up detail and the look of the lighter metal in the pieces.

▲ I placed a small mirror on the left to reflect into the cross on the king (the piece in the right foreground) to give it more separation from the background.

▲ I added a diffuser to soften the overall activity in the shot and to give it a bit of a glow. I also added a pastel filter, a Fog #2, to soften the image by increasing the image break-up. But this was more diffusion than I really wanted.

▲ I reduced the diffusion and changed to a Fog #1 filter with the results you see here.

▲ I decided to go with a slightly shorter exposure in order to get darker, crisper shadows.

▲ As you can see from the image we used for the brochure, I did a little computer manipulation as well. I admit this is a long way to go for an image, but I really think in this case the new technology made a major contribution to creating the soft, romantic feeling the shot needed.

Client: The Cincinnati Opera
Marketing Director: Patti Beggs
Photographer: Alan Brown
Art Director: Liz Kathman Grubow
Design Studio: Libby, Perszyk, Kathman
Special Equipment: Canon Electronic Still
Video Camera, Macintosh Computer

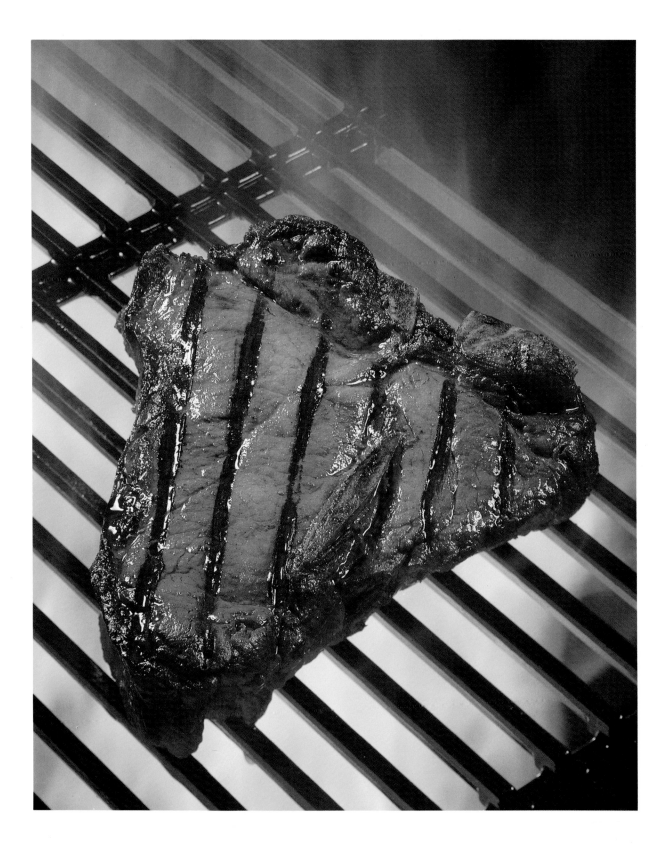

A subject can be lit to suggest that it is in a particular place or environment. This is another type of lighting for effect that helps convince the viewer that the subject is in the place that the props, backgrounds, and surfaces are trying to suggest. For example, in this photo I had a warm steak and wanted to have a fire burning for only a few seconds, but I would use the lighting to convince the viewer that the steak was sizzling over the grill instead.

I shot this photograph for our food portfolio to show we can shoot a situation featuring beef. I wanted to show the steak being grilled with flames licking the edges the way it would be in a barbecue pit or on a grill. I felt the action of the flames and their color would help make the steak look more attractive and inviting by bringing to mind the sights and smells of a barbecue. I was able to achieve this effect with three lights.

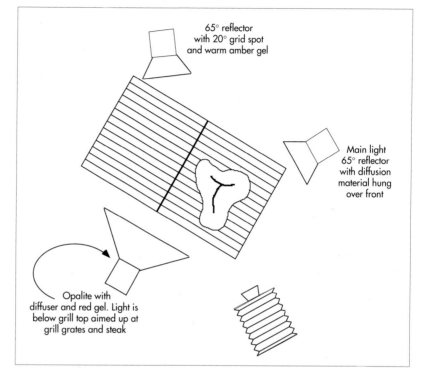

65° reflector
with 20° grid spot
and warm amber gel

Main light
65° reflector
with diffusion
material hung
over front

Opalite with
diffuser and red gel. Light is
below grill top aimed up at
grill grates and steak

▲ When I had figured out the height and density for the flames, I shot them in my first exposure. I set the camera lens on T and turned the modeling lights off. I lit the Bestine rubber cement thinner and charcoal. The flames would burn brightly for about five seconds, which was just enough time to trip the shutter and set off the electronic flash heads while simultaneously exposing the film to the burning flames. Then I shot my second exposure with all the lights shown above on.

▶ As the main light for the steak itself I chose a 65-degree reflector with a piece of translucent diffusion material hanging off it, so that I had a narrow focused light source that would light only the top surface of the steak and add a few highlights to the grill. This kept the other areas of the photo dark so I could selectively add just the right amount of red color to hit the grill grates and the edge of the steak. This also helped when I added the flames to the shot, because nothing would show through the flames when they were double-exposed onto the final film.

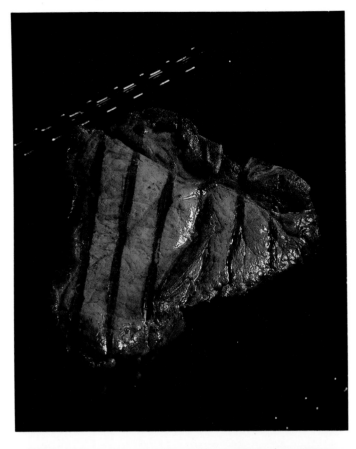

▶ Here's the effect of adding a skim light with an amber gel set behind and left of the grill, about twenty-four inches above the grill. This light does two things. First, it gives the steak a more appetizing color—notice the difference in the color of the meat between stages one and two. Second, this light adds nice little highlight areas to the surface of the meat to help make the meat look hot.

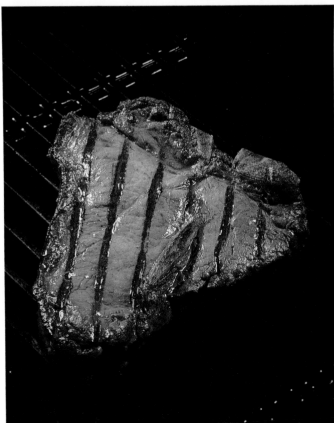

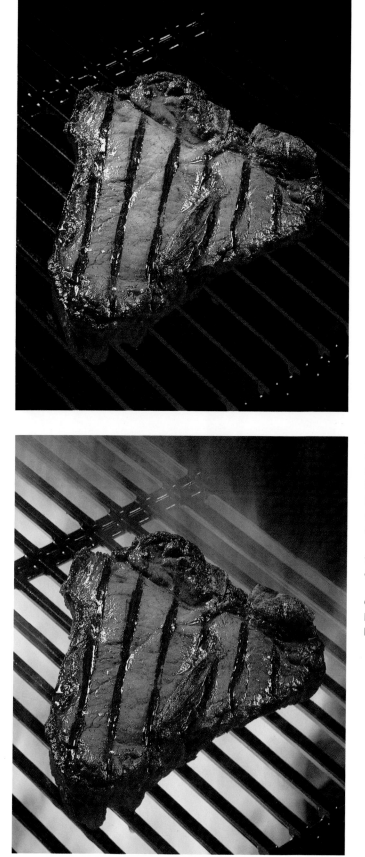

◀ Now I've added a third light, which has a red gel added. This adds the red glow to the grill grates and around the edges of the steak to suggest red embers glowing under the grill. I didn't want to show embers in the photo, because I felt they would detract from the steak too much. So I used the red gel instead, using the power of suggestion where literal means were not appropriate or desirable.

◀ The last ingredient I needed for the photo were the flames. I created these by filling a metal pan with charcoal and putting it under the grill grates and adding Bestine to it. I had to experiment a lot—keeping safety in mind as well as effect—to determine the correct amount of thinner.

And here it's all come together for the look that I was trying to achieve—a steak sizzling on the grill.

Client: PhotoDesign self-promotion
Photographer: Joe Braun
Food Stylist: Lisa DeVille

LIGHTING FOR EFFECT: USING A SUBTRACTIVE APPROACH

Originally Lisa DeVille—the food stylist who collaborated with me on this project—and I wanted to do a champagne pour shot. So we shot a setup with champagne coming out of the end of the bottle and falling into an elegant champagne glass. But we felt that the shot lacked interest and excitement—it even made the champagne look quite boring. We experimented with different intensities of pours and began to use compressed air combined with the champagne. Now the champagne looked very exciting and interesting as the liquid whooshed out of the bottle. It didn't fit very well, however, with the delicate glass. We decided it was better to keep the look of the liquid combined with the compressed air, so we changed to a champagne bottle being opened with the cork flying out.

Compressed
air line to
neck of bottle

◀ We had to set up this shot upside down from how it would be viewed on the final transparency—the liquid would actually be falling towards the floor even though it would look like it was shooting up and out of the bottle. This way the logo would read right side up when the transparency was viewed in the final form. Getting the pour to look right took a lot of experimenting with different amounts of liquid and compressed air. The liquid was poured into the back of the bottle, which I had cut off at a local glass shop. The air ran into the neck of the bottle through a $1/4$-inch tube also inserted from the rear.

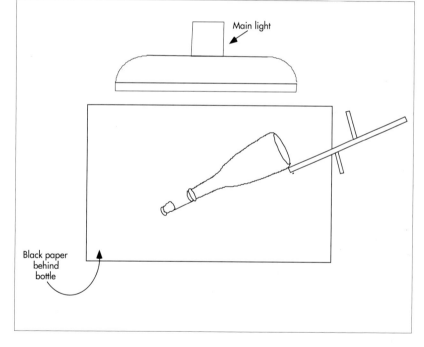

Main light

Black paper
behind
bottle

◀ Sometimes lighting for effect requires a subtractive approach. When I use this term I mean lighting a broad area then using black, gray, or white cards to mask off areas of the light to create shadows, middle tones, or (in a very few cases) highlights. This photograph that I did as a self-assignment is a good example of this approach.

I ended up lighting both the original and the "Champagne Pop" version the same way. I started with a 42-inch-square overhead lightbox positioned 18 inches above and slightly to the rear of the bottle. Positioning the light this way allowed me to backlight the liquid "gushing" from the bottle to give the liquid and steam a nice brightness and intensity.

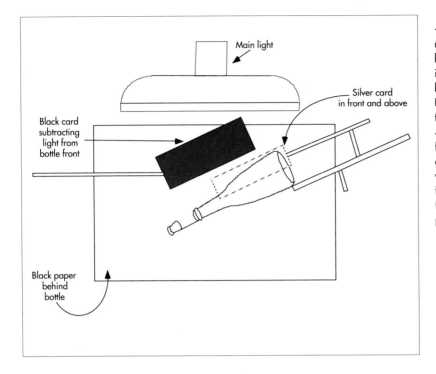

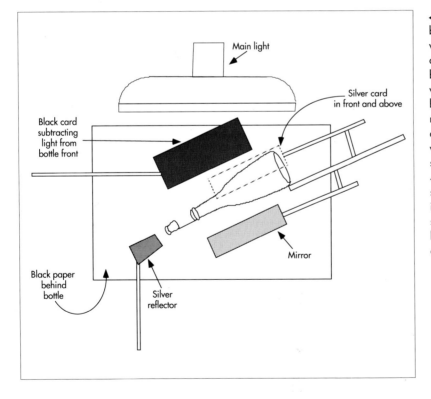

◄ Next I subtracted some of the light that was reflecting into the labels and the glass bottle by inserting a black card above and slightly in front of the bottle. This toned down the brightness in the foil label and in the glass. However, this took a bit too much light off of the front of the bottle and label, so I added a 4" x 8" silver foil reflector and positioned it in front and slightly above the camera. This added a shiny highlight of the intensity I wanted running through the Moet logo on the foil label and brightened the ribbon and finally opened up some detail in the black part of the label, the glass, and the cork.

◄ Then I wanted to add a highlight to the bottom (which would become the top when viewed upside down in the final image) of the champagne bottle and label so that it didn't blend into the black background. I did this with a 4" x 6" mirror positioned below the bottle and slightly behind. This also made the ribbon look more attractive by adding a couple of nice highlights to the edges that were facing down toward the bottom of the set. The last lighting touch was to add a 4" x 4" silver reflector right in front of and slightly below the cork to open up some detail in the green metal top. The cork itself was supported by a thin skewer stuck into the bottom of the cork and then glued to the inside of the neck of the bottle out of sight.

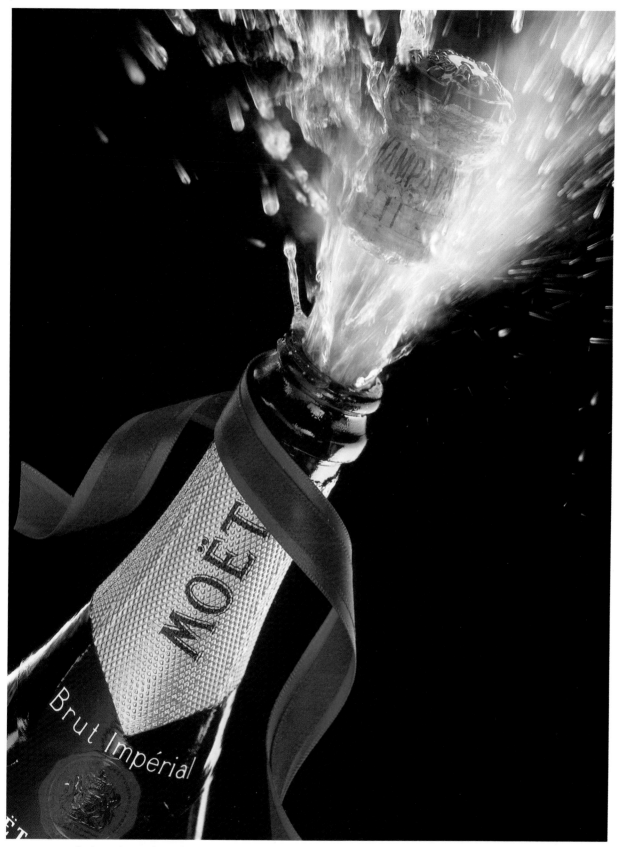

▲ Approximately thirty sheets of 4x5 film were exposed to get just the right amount of whoosh, liquid, and air coming out of the end of the bottle.

Client: Photo Design self-promotion
Photographer: Joe Braun
Food Stylist: Lisa DeVille

Index